Dedalus European Classics

Tales from the Saragossa Manuscript
Jan Potocki

"The *Manuscript* reveals a kind of Polish Beckford. There are gorgeous descriptions, fantastic turqueries and gothic horrors. But Potocki's debts were in fact multiple. To begin with, the book is a compendium of eighteenth century fictional forms. There are picturesque adventures and tales of vengeance, banditry, manners and love, while shivery echoes of the *roman noir* jostle with reverberations from the *conte philosophique* and the magical, erotic *conte oriental*, which calls to mind Lesage, Voltaire, Crebillon fils, Cazotte, *Munchausen*, Restif, Diderot, the Casanova of the *Icosameron* and the Sade of the *Historiettes*. But the *Manuscript* is also an anthology of Enlightenment rationalism. The irony is Voltairean and the sensibility Rousseauistic. Its materialism recalls Diderot and La Mettrie. It contains more than a whiff of hermetic philosophy and, though Potocki did not belong to any known lodge, perhaps a hint of Masonic symbolism, together with clear elements of comparative mysticism derived from sources as eclectic as the Talmud, the cabbala and modern 'illuminists' such as Saint-Martin."

Times Literary Supplement

Translated from the French by Christine Donougher

Tales from the Saragossa Manuscript

(Ten Days in the Life of Alphonse Van Worden)

By Jan Potocki

with an introduction by
Brian Stableford

Dedalus / Hippocrene

Published in the UK by Dedalus Ltd,
Langford Lodge, St Judith's Lane, Sawtry, Cambs. PE17 5XE
Published in the USA by Hippocrene Books Inc.,
171 Madison Avenue, New York NY10016

UK ISBN 0 946626 67 7
US ISBN 087052 936 6

First published in France in 1814
Dedalus edition 1990

Translation copyright © Christine Donougher 1990
Introduction copyright © Dedalus 1990

Printed in England by Clays Ltd, St Ives plc

A CIP listing for this title is available on request

Cover picture is by Salvator Rosa from the
National Gallery – London

THE TRANSLATOR

Christine Donougher was born in 1954. She is of Liverpool-Irish and French parentage, and studied English Literature and French at Cambridge University. After several years as an editor in publishing, she now works freelance and has translated a number of books, both fiction and non-fiction. Her current projects include new translations of the second part of *The Saragossa Manuscript* (*The Adventures of Avadoro*) and J. K. Huysmans' *La-Bas*.

THE EDITOR

Brian Stableford was born in Shipley, Yorkshire in 1948 and studied Biology at the University of York, before doing a D.Phil in Sociology. He combined for twelve years a career as a writer of science fiction and scholarly works with teaching the sociology of the novel at Reading University. He is now a full-time writer.

His most recent novels include *The Empire of Fear* and *The Werewolves of London*; while his non-fiction works include *The Sociology* of *Science Fiction* and *Scientific Romance in Britain 1890–1950* and the forthcoming *Dedalus Book of Decadence* (*Moral Ruins*).

INTRODUCTION

by Brian Stableford

The history of *The Saragossa Manuscript* is at least as curious as the contents of the text, and features several unanswered questions.

The currently accepted modern version of its provenance and nature asserts that it was the literary *magnum opus* of a famous Polish nobleman, whose other works are mostly accounts of his travels. The fact that only parts of it were published during his lifetime, and those discreetly, is held to be explained by his extraordinarily busy life, which is assumed to have made it impossible for him to supervise its complete publication in its proper form.

Though this account may well be true it is not beyond doubt, nor does it settle all the problematic questions which surround the text. Some of these problems will undoubtedly remain unsolved, just as *The Saragossa Manuscript* itself – if such a work ought to exist at all – will never be complete.

The fullest edition of *The Saragossa Manuscript* – which claims to be missing only one "lost" section – was first issued in Poland more than thirty years after the supposed author's death. But this was a translation into Polish of material initially written in French (French being the language of the aristocratic circles in which its supposed author moved). No French edition of the work in this form ever appeared, but there are three printed documents in French which considerably antedate the Polish edition and contain material later incorporated into it.

One of these French-language publications – untitled, unsigned, undated and with no indication of place of publication – is now said to have been published in two

volumes in St Petersburg. The other two, which reprint almost all of the material in the first, though in somewhat different form, were published in four and three volumes respectively in Paris in 1813 and 1814.

Although these documents were the source of some controversy in their day they fell into obscurity during the latter part of the nineteenth century, and were virtually forgotten until the 1950s, when Roger Caillois took the trouble to excavate them from the Bibliothèque Nationale and the Leningrad Library in order to issue a new edition of those sections which most interested him. This venture, assisted by renewed academic interest in the work in Poland, launched a new wave of interest in the work and began a concerted attempt to "restore" a full version of the text in its original language.

The authorship of the two Paris-published documents was a matter of some dispute between the various bibliographers who attempted to bring some order to the accumulate history of French literature in the early nineteenth century. According to A.-A. Barbier, author of the *Dictionnaire des Anonymes*, their author was the celebrated Count Jan Potocki (an opinion endorsed by the Polish edition of 1847). The more prestigious bibliographer Jean-Marie Quérard, however, disagreed with this view, insisting that the true author was the far more obscure Jozef Potocki (whose relationship to the aforementioned Jan he did not take the trouble to specify). A third bibliographer, Paul Lacroix, disagreed with both of them, attributing the two works to the French Romantic writer Charles Nodier.

Caillois unhesitatingly accepts the attribution to Jan Potocki, on the grounds that Barbier knew – as the others did not – about the earlier St Petersburg document. It is not entirely clear, however, what evidence there is to support this conclusion apart from that based in Barbier's assertions. Barbier certainly seems to have had in his

possession the only known copy of the first volume of the relevant document, which was eventually presented to the Bibliothèque Nationale in 1889. This has a title added in ink (which includes the words *Manuscrit trouvé à Saragosse,* and thus bestows upon the work the title by which it is nowadays known) and the name "Jan Potocki" in pencil. If these additions were made by Barbier – who is presumably also responsible for the allegation that the date of this publication was 1804 – we have no word but his to support his attribution. Normally, of course, one would not doubt him – but Jean-Marie Quérard did, and seems to have taken some trouble to make enquiries.

Another handwritten addendum to this volume (probably also by Barbier) charges Charles Nodier with having attempted to plagiarize the work after a manuscript copy of it was given into his care. Lacroix later claimed to have had a handwritten version of at least one of the Paris documents, given to him by Nodier, but his claim that this proves Nodier's authorship is dismissed out of hand by Caillois, who points out that this is disproved by the existence of the St Petersburg text of 1804. But how certain can we be that the text in question was published in 1804, or in St Petersburg?

The strongest independent evidence of the provenance of the document in question is that the only known copy of the second (fragmentary) volume of the document is lodged in the Leningrad Library. There, Caillois tells us, it is filed under the heading "Potockiana", and also has a handwritten note attached attributing the work to Jan Potocki and giving the date of its publications as 1805. Again, if we take things at face value, this settles the matter – but how and when did the document get to St Petersburg/Leningrad, and who made the handwritten note? (It is worth remembering that the other volume only reached the Bibliothèque Nationale in 1889.)

It is not clear whether there is any independent evidence, outside of the handwritten notes added to these two volumes, of the place, date or authorship of the

documents; they certainly do not constitute a real edition of the text, being only proof copies. In view of Quérard's willingness to dissent from Barbier's view there must remain a possibility that the attributions are inauthentic in some or all of these respects, even though one volume ended up in Paris and the other in Leningrad.

On the other hand, it is not clear either what reason Quérard had for rejecting Barbier's attribution; he does mention having consulted Countess Rzewuska – a member of the Potocki family – on the subject, but implies (somewhat perversely) that her testimony was that the work in question was not known to the Potocki family at all.

Caillois, introducing his edition of the first part of a "restored" *Saragossa Manuscript* says that certain key fragments of the original French text had been recently located in an archive of the Potocki family; the existence of these does seem to rule out Nodier as a putative author of the work, but does not necessarily settle the question of which Potocki was responsible. Caillois seems certain that all the texts are entirely the work of Jan Potocki, and this is obviously the most likely hypothesis – but one cannot help but wonder what foundation Quérard's doubts may have had.

The Potocki family was one of the great aristocratic houses of Poland for hundreds of years. It had many notable members before and after Jan, including several great statesmen, numerous distinguished soldiers and one other notable writer – the semi-repentant heretic Waclaw Potocki (1625-97), whose most famous work was an epic poem celebrating the military adventures of his people.

Whether or not he wrote *The Saragossa Manuscript* Jan Potocki (1761-1815) certainly broke considerable new ground in extending the contribution made by his august family to the political and cultural life of the nation. He was a great traveller, and he published several accounts of

his journeys to distant parts of the world; nor did he go as a mere tourist, for he became a serious ethnologist, historian and pioneer of archaeology, writing extensively on these subjects. He won a certain celebrity in 1789 by making a balloon ascent, and briefly served as an officer in the Engineering Corps.

Later in life, when he was a special adviser to Tsar Alexander I, Jan Potocki was appointed head of a scientific mission which was supposed to accompany the Tsar's embassy to Peking in 1805 (according to the note in the volume in the Leningrad Library it was this adventure which abruptly interrupted publication of the St Petersburg manuscript). Alas, the expedition was a failure; the embassy was turned back by the Viceroy of Mongolia. Afterwards, Jan's once-glittering career seems to have gone steadily downhill; he eventually retired to his estates in 1812 – at which point he supposedly took it into his head to continue the story which he had abandoned seven years before, preparing two parts of it for publication in Paris. If he intended to do more he never put his plans into operation; he committed suicide in 1815.

Caillois, in typical French fashion, cavalierly attributes Potocki's suicide to the effects of "depression" and "neurasthenia", but neither of these terms actually serves to explain anything. We may be certain, however, that if Jan Potocki did indeed write them, the two parts of *The Saragossa Manuscript* which were issued in Paris were produced while the author was living through a time of person troubles. This is worth noting, because the values tacitly expressed in the work are not at all those one might expect to be embraced by a contented member of Potocki's class; they are wholeheartedly picaresque, and their view of both Church and Aristocracy are distinctly jaundiced.

The text of the two volumes which were supposedly printed in St Petersburg in 1804 and 1805 describe the

strange and macabre adventures which befall a Spanish soldier named Alphonse van Worden after he is unwise enough to sleep in a haunted inn. These extend over thirteen days, and include various tales told by him and to him, which eerily reflect and recomplicate the predicament in which he now finds himself. The text ultimately breaks off in mid-sentence. Whether any more of the work had actually been written at this point in time we do not know, though the note in the Leningrad volume implies that it had not and the eventual continuation of the narrative takes it in a very different direction.

The first of the documents printed in Paris consists of four volumes entitled *Avadoro, histoire espagnole, par M.L.C.J.P.* The work begins, by way of introduction, with the last two sections of the St Petersburg text, in which Alphonse van Worden meets the gypsy chief Avadoro. It continues to relate a series of tales to Alphonse by Avadoro, including the story of his own life and various stories told to him by people he has met – but despite a certain formal similarity and a few supernatural intrusions *Avadoro* is markedly different in its subject-matter from the rest of the St Petersburg text, being much less strange and not really macabre at all.

The second Paris document consists of three unsigned volumes entitled *Dix journées de la vie d'Alphonse Van Worden* (i.e. *Ten Days in the Life of Alphonse van Worden*). It comprises a slightly revised version of the remainder of the St Petersburg text, but it omits one day from the narrative and adds one extra episode to serve as a conclusion.

The chapter of the St Petersburg text which is omitted from the 1813-14 editions is Day 11 of Alphonse's adventure, which recapitulates two anecdotes retold from well-known classical sources. Caillois presumes that this was omitted simply because it was not original, but the eleventh day is the one during which the story undergoes its crucial change in direction: it might conceivably have

been an awareness of the fact that his story had here turned a significant corner which led the author to abandon his original plan for publication of the work, in order to recast it.

This is a point of some significance, because Caillois takes it for granted (apparently following Barbier) that the two Paris editions should be seen as mere excerpts from a much larger work which must properly be considered as a whole. In fact, the notion that there "ought" to exist a French-language work entitled *Manuscrit trouvé à Saragosse*, translatable into English as *The Saragossa Manuscript*, is entirely the idea of later collators and commentators. Even if we set aside doubts about the true authorship of the work and attribute it to Jan Potocki, we still cannot tell whether the two French editions represent his final intentions regarding his fictional canon or whether he might – if he had lived – have gone on to insert these texts into a much larger book, as the editor of the 1847 Polish edition eventually did. It is certainly possible that the two Parisian editions feature the author's own preferred version of his text, and that the "whole work" which Caillois and others are striving to "restore" should be regarded as nothing more than a set of drafts for a deliberately aborted project.

The Polish edition of 1847 was issued in six volumes, and ostensibly contained as much of the text as was then recoverable. Only a part of the French-language text supposedly used in this translation could still be found in the Potocki family archives when interest in the work was renewed in the 1950s. The task of restoring a complete text in the original language of composition, therefore, requires translation into French of about a fifth of the total wordage of the Polish edition. In these circumstances it is difficult in the extreme to make any conclusive judgement about the authenticity of the Polish text; it is at least possible that parts of it were the work of a different writer.

When all of this is taken into account, one can only conclude that the attempt to achieve a complete restora-

tion of an unpublished masterpiece by Jan Potocki might in the end turn out to have been a wild goose chase – but in the particular context of the early part of the story, which is here presented in a new English version, such doubts and confusions take on a certain ironic propriety; there are no other texts of the period which are quite so rich in ambiguity and deceptiveness.

In the form which scholars are now trying to "restore" to it, *The Saragossa Manuscript* echoes such famous works as Boccaccio's *Decameron*, Basile's *Pentamerone* and Marguerite of Navarre's *Heptameron*, but only faintly. These earlier models are compendia of tales which are presented as anecdotes narrated by a group of characters who have time to while away; in Boccaccio's classic a group of young noblemen taking refuge from the Black Death take it upon themselves to collaborate in telling ten stories a day for ten days.

Although Potocki's story is also broken up into days, during most of which the central character tells or hears one or more stories, its structure is both much less tightly organized and much more intricate, sometimes embedding tales within other tales after the fashion of the *Thousand-and-One-Nights* (which had been translated into French by Galland between 1704 and 1717). This process of recomplication is intensified in its early stages by an extra dimension of uncertainty which is imported into the narrative of *Ten Days in the Life of Alphonse van Worden*. In the days which follow his unfortunate night spent in the haunted inn Alphonse twice wakes up under a gallows in the company of two hanged men who may or may not be inhabited each night between midnight and cockcrow by the spirits of two playful demons. At least some of his experiences, therefore, appear to be hallucinatory, and there is an evident possibility that he has become lost in a maze of experiences in which it will ultimately become impossible to separate dream from reality.

In the "restored" manuscript of the Polish edition this ambiguity is soon set aside, and is forgotten for most of the book before it is eventually cleared up in a rather crude and unconvincing fashion – a move which is not to the benefit of the work, and constitutes a strong argument for letting the *Ten Days* stand as it is instead of insisting on rejoining it to the whole. One could certainly argue that the incompleteness of the *Ten Days* reflects the un-resolvability of the predicament in which Alphonse finds himself, and that is has a certain propriety which is lost if it is reconnected to *Avadoro*.

Whether this is accepted or not, it is certainly the case that there are some very striking features of the *Ten Days* which deserve careful consideration in isolation from anything which happens in *Avadoro* or in the remaining fragments of the whole text.

One very interesting feature of the *Ten Days* is the way in which the doubts which Alphonse must entertain on his own behalf (as to whether the two seductive "sisters" who promise him great wealth and sumptuous erotic delights if he will only abandon his Christian faith are really hideous demons in disguise) are reflected in the tales which he is told by other characters. The madman Pacheco suffers a similar temptation to troilism by his stepmother and her sister, who are similarly linked with the two hanged men; the cabbalist Sadok Ben Mamoun is employing his arts in a quest to discover two legendary "immortal brides" who bear the same names as Alphonse's "sisters".

The repetition of this troilistic motif is not the only unusual feature of the way in which Alphonse's tempta-tions are represented in the *Ten Days*. There is also the peculiar fashion in which he retells two stories first told to him by his father, both of which feature characters who have gruesome encounters with the risen dead. Before resolving the conclusion of each story Alphonse's father asks him whether he would have been afraid had he found himself in such a situation. In the first instance Alphonse

enrages his father by admitting that he would; in the second he is careful to issue a stout – but presumably insincere – denial. Now, apparently, he finds himself in a situation of the same kind as those which have featured so significantly in his fabular education, and the question of whether he should exhibit fear seems just as acute as the question of whether his immortal soul is endangered by temptation. He certainly pretends fearlessness, both in narrating the story to an assumed reader and in talking to the other characters, but the inclusion of these two anecdotes must call into question the reliability of this appearance.

One is, of course, strongly tempted to conclude that both of these interesting features must have had some particular personal significance for the author. The fact that he subsequently veered away from both of them, leaving them unsettled in order to carry forward a much more mudane narrative – in which Avadoro replaces Alphonse van Worden as the central character – may reflect the fact that he found their literary embodiment too uncomfortable to sustain. On the other hand, he may simply have returned to his work in 1812 a man whose interests and convictions had changed very markedly since he left it in 1805.

In any case, having projected Alphonse into this fascinating state of uncertainty and made him vulnerable to all manner of nightmares, the "restored" work simply abandons him there while following other trails, until tamely redeeming him at a much later date; this cannot be satisfactory from the point of view of the reader, and it is difficult to believe that the author found it satisfactory either – his decision to make a separate work out of *Avadoro* is much more reasonable than the pursuers of a "restored" text tend to imply.

Viewed as an entity in its own right, *Ten Days in the Life of Alphonse van Worden* is undoubtedly incomplete – but the relevant extensions which are intriguingly implied by its concerns certainly do not include *Avadoro*. It seems

entirely reasonable to regard the *Ten Days* as the beginning of what might have been a classic work of supernatural fiction, and one suspects that whatever explanation may eventually have been given of Alphonse's adventures would have been much more concerned with the allegories and mysteries of cabbalism than the pranks of gypsy girls. *Avadoro* is a very different kind of work; although some of the tales embedded in it are supernatural they take the form of conventional cautionary anecdotes about the temptations of greed – temptations quite different from those which feature so phantasmagorically in the *Ten Days*. The frame narrative of *Avadoro* is determinedly mundane, and the explanation of what earlier befell poor Alphonse which is appended to the Polish edition is simply silly.

Whatever kind of whole the "restored" text of *The Saragossa Manuscript* may be, therefore, it is definitely not the work whose beginning the *Ten Days* properly constitutes; that work does not exist and never can. It will undoubtedly be fascinating to have a complete collection of those various pieces which Potocki wrote within the loose framework of his putative Heptameron, but if we are to make sense of it we must be very wary indeed of viewing it as if it were anything more than a patchwork of loose ends.

The loss of the classic work of supernatural fiction whose beginning *Ten Days in the Life of Alphonse van Worden* seems to be must be reckoned a tragedy; in many respects the text is way ahead of its time. It has touches of satirical wit and narrative audacity which bring it into very sharp contrast with the Gothic tales of terror with which it was contemporary. Its analysis of the psychology of temptation promised to be much more daring and perspicacious than anything which had gone before, and the philosophical conclusions which would have followed as corollaries from that account would surely have been fascinating.

Perhaps, alas, it was too far ahead of its time actually to be written; had it actually become a significant intellectual journey into the exotic hinterlands of heretical mysticism it would surely have startled those who knew the author and – assuming that he was a Potocki – shocked his august family. We can only speculate now about how close the connection may have been between the motives which cut short the most interesting part of this literary endeavour and the motives which led Jan Potocki to cut short his own life, and the uncertainty of any such speculations can only serve to add an extra dimension to that great puzzle which is *The Saragossa Manuscript*.

FOREWORD

As an officer in the French Army, I found myself at the siege of Saragossa. A few days after the town was taken, having advanced to a lonely spot, I noticed a tiny house, quite well built, that I thought at first had not yet been visited by a single Frenchman.

I was curious to go inside. I knocked at the door, but I saw that it was not shut. I pushed it open and entered. I called out, I looked around, found no one. It seemed to me that everything of value had already been taken; there remained on the tables and in the cupboards only objects of little importance. However, I noticed on the floor, in a corner, several notebooks of handwritten pages. I glanced at the contents. It was a Spanish manuscript. I knew very little of this language, but yet I knew enough to realize that this book could be amusing: it was about brigands, ghosts, cabbalists, and nothing was more apt to distract me from the tedium of the countryside than reading a bizarre novel. Convinced that this book would never be restored to its legitimate owner, I had no hesitation in taking it for myself.

Subsequently, we were obliged to leave Saragossa. Having been separated, as ill luck would have it, from the main body of the army, I was taken with my detachment by the enemy. I thought my fate was sealed. After reaching the place where they were taking us, the Spanish began to strip us of our belongings. I asked to keep only one object, which could be of no use to them: it was the book I had found. They made some difficulty at first; finally they asked the advice of the captain who, having glanced at the book, came to me and thanked me for having preserved intact a work to which he attached great value, since it contained the story of one of his forebears. I told him how it had fallen into my hands. He took me with him, and during my rather lengthy stay in his household, where I was quite well treated, I asked him to

translate this work for me into French. I wrote it down at his dictation.

THE FIRST DAY

The Comte d'Olavidez had not yet established foreign colonies in the Sierra Morena. This range that separates Andalusia from La Mancha was then inhabited only by smugglers, bandits, and a few gypsies, who were said to eat the travellers they had murdered – whence the Spanish proverb: *Las gitanas de Sierra Morena quieren carne de hombres.*

And that's not all. The traveller who ventured into this wild country would, it was said, there find himself assailed by a thousand terrors capable of chilling the boldest spirits. He would hear wailing voices mingling with the rushing of mountain streams and the whistling of the storm, deceptive lights would lead him astray, and invisible hands push him towards bottomless abysses.

In truth, a few *ventas*, or isolated inns, were scattered along this ill-omened road, but ghosts, more devilish than the highwaymen themselves, had forced the latter to retire to areas where their rest was troubled no more except by the reproaches of their conscience – with such phantoms do innkeepers come to some arrangement: the one at the Andujar hostelry would swear by St James of Compostella to the truth of these marvellous accounts. Indeed, he would add that the archers of St Hermandad had refused to undertake any expedition to the Sierra Morena, and that travellers took the road to Jaen, or to Estremadura.

In reply I told him that this option might suit ordinary travellers, but that since the King, Don Felipe Quinto, had been so gracious as to honour me with a captain's commission in the Walloon Guards, the sacred laws of honour forbade me from reaching Madrid by the shortest route without asking if it was the most dangerous.

"My noble young sir," resumed my host, "Your Lordship will permit me to point out to him that if the King has honoured him with a company in the Guards before

age has honoured Your Lordship's chin with so much as the lightest growth of hair, it would be expedient to display prudence. Now, let me tell you, when evil spirits take over a place…"

He would have said more, but I dug in my spurs and did not stop until I thought myself beyond the range of his remonstrances. Then I turned round and saw him gesticulating still and pointing out to me in the distance the road to Estremadura. My manservant, Lopez, and Mosquito, my *zagal*, were giving me pitiful looks, whose meaning was roughly the same. I pretended not to understand and rode on into the heathland, where the colony called La Carlota has since been built.

In the very spot where the post house stands today, there was then a shelter, well known to muleteers, who called it Los Alcornoques, or the holm-oaks, because in this place two fine trees of this species cast their shade over an abundant spring that collected in a marble drinking-trough. This was the only water and the only shade to be found between Andujar and the inn called Venta Quemada. This inn was built in the middle of nowhere, but it was big and spacious. It was actually an old Moorish castle, destroyed a long time ago in a fire, and since restored and turned into an hostelry, which was how it came by the name of Venta Quemada. It was run by a man of means. So travellers would leave Andujar in the morning, dine at Los Alcornoques on provisions they had brought with them, and then spend the night at Venta Quemada. Often they would even spend the following day there, to prepare themselves for the mountain crossing and to renew their supplies. This was also the plan for my journey.

But as we were already approaching the holm-oaks, and I was talking to Lopez of the light meal we were planning to have there, I noticed that Mosquito was not with us, nor the mule loaded with our provisions. Lopez told me that the boy had stopped some hundred paces behind to retie something on his mount's harnessing. We

waited for him, then went on a few paces, then stopped to wait for him again; we called him, we retraced our steps to look for him: all to no avail. Mosquito had disappeared and taken with him our dearest hopes – in other words, our entire dinner. I was alone in not having eaten at all, for Lopez had been constantly gnawing on a Tobosa cheese, with which he had provided himself, but he was none the merrier for that, mumbling beneath his breath that the innkeeper at Andujar had warned us, and that evil spirits had surely carried off the luckless Mosquito.

When we arrived at Los Alcornoques, I found on the drinking-trough a basket filled with vine-leaves. It looked as though it had been full of fruit and was left behind by some traveller. I searched it with curiosity and had the pleasure of finding in it four lovely figs and an orange. I offered two figs to Lopez, but he refused them, saying that he could wait until the evening. So I ate all the fruit, after which I would have quenched my thirst at the nearby spring. Lopez stopped me, alleging that the water would be bad for me after the fruit, and that he had the remains of some Alicante wine to offer me. I accepted his offer, but hardly was the wine in my stomach when I felt extremely unwell. I saw the earth and the sky spinning above my head, and I would certainly have fainted had Lopez not rushed to my aid. He helped me recover from my attack and told me that it was no cause for alarm, being simply a result of tiredness and lack of food.

Indeed, not only had I recovered, I was in a state of health and excitement that had an extraordinary quality about it. The countryside seemed to me enamelled in the most brilliant colours; objects scintillated before my eyes like stars in summer nights, and I felt my arteries throbbing.

Seeing that my indisposition had passed without sequel, Lopez could not help resuming his complaints.

"Alas," he said, "why did I not pay attention to Fray Geronimo of Trinidad, monk, preceptor, confessor and oracle of our family. He is the brother-in-law of the

son-in-law of the daughter-in-law of my mother-in-law's father-in-law, and being the closest relation we have, nothing is done in our house except on his advice. I refused to follow it and have been justly punished. He told me that the officers of the Walloon Guards were an heretical lot, this being easily recognizable from their blond hair, their blue eyes, and their red cheeks, whereas the old Christians have the colouring of Our Lady of Atocha, as depicted by St Luke.

I put a stop to this torrent of impertinent remarks by ordering Lopez to give me my double-barrelled shotgun and to stay with the horses while I climbed some rocky eminence in the vicinity in an attempt to discover Mosquito's whereabouts, or at least his trail. At this suggestion Lopez burst into tears, and throwing himself at my knees, he called upon me, in the name of all the saints, not to leave him alone in a place so full of danger. I offered to look after the horses myself while he went exploring, but this alternative seemed much more terrifying to him. However, I gave him so many good reasons for going in search of Mosquito that he let me depart. Then he drew a rosary from his pocket and began praying by the watering-trough.

The heights I wanted to climb were further than I had thought. It took me an hour to reach them and when I got there I saw nothing but the wild deserted plain: no sign of man, or beast, or habitation, no road but the one I had been following, and not a soul was travelling on it; and all around, the utmost silence. I broke it with my shouts, which re-echoed in the distance. Eventually I retraced the path to the watering-trough, where I found my horse tied to a tree. But Lopez had disappeared.

I had two choices: to return to Andujar, or to continue my journey. But the first option did not even occur to me. I leapt onto my horse, and at once setting it at a brisk trot, in two hours I reached the banks of the Guadalquivir, which is not that quiet splendid river whose majestic course embraces the walls of Seville. The Guadalquivir as

it leaves the mountains is a bottomless boundless torrent, ever roaring against the rocks that contain its strenuous waters.

The valley of Los Hermanos begins at the place where the Guadalquivir spreads out across the plain. It is so called because three brothers, united less by blood kinship than by their taste for brigandage, for a long time made it the scene of their exploits. Of the three brothers, two had been captured and their bodies could be seen strung up on a gibbet at the entrance to the valley; but the third, called Zoto, had escaped from the prisons of Cordoba, and was said to have taken refuge in the Alpujarras mountain range.

Very strange tales were told about the two brothers who had been hanged. They were not referred to as ghosts but it was claimed that their bodies, animated by some evil spirit, would free themselves at night and leave the gibbet to go haunting the living. This was considered such a sure fact that a theologian from Salamanca had written a dissertation in which he argued that the two hanged men were a kind of vampire, and that the one theory was no more incredible than the other – this the most incredulous freely granted him. There was also a certain rumour that these two men were innocent, and having been unjustly condemned, were taking their revenge, with heaven's licence, on travellers and other passers-by. Since I had heard much talk of all this at Cordoba, I had the curiosity to approach the gallows. The spectacle was all the more disgusting as the hideous cadavers, caught by the wind, swung about in the most extraordinary manner, while frightful vultures pulled at them, tearing off strips of flesh. I averted my eyes in horror, and rode headlong down the mountain road.

It must be admitted that the Los Hermanos valley seemed to lend itself very well to the exploits of bandits, and to serving them as a refuge. The traveller was stopped in his tracks sometimes by rocks broken loose from mountaintops, sometimes by trees uprooted by storms.

In many places the path crossed the riverbed or passed in front of deep caves whose forbidding aspect inspired caution.

At the end of this valley I entered another and saw the Venta that was to be my shelter for the night. But from the moment I laid eyes upon it, I expected nothing good of it. For I could see it had no windows or shutters; there was no smoke from the chimneys; I saw no sign of activity nearby, nor did I hear the dogs give warning of my arrival. From which I concluded that this tavern was one of those that had been abandoned, as the innkeeper at Andujar had told me.

The closer I came to the Venta, the deeper the silence seemed to me. At last I arrived and I saw a box for collecting alms, accompanied by an inscription worded thus: "Gentlemen travellers, have the charity to pray for the soul of Gonzalez of Murcia, late the keeper of Venta Quemada. Above all else, continue on your way and do not stay the night here, under any pretext whatsoever."

I at once decided to brave the dangers with which the inscription threatened me. It was not that I was convinced there are no ghosts, but it will be seen later that my entire education had been directed towards honour, and for me this consisted of never showing any sign of fear.

Since the sun was just setting, I wanted to take advantage of the remaining light to examine every nook and cranny in this building, less to relieve myself of anxiety regarding the infernal powers that had taken possession of it than to search for food, for the little I had eaten at Los Alcornoques had served to allay but not to satisfy the imperative need I felt of some sustenance. I walked through many rooms and chambers. Most were covered with mosaics to the height of a man, and the ceilings were of that fine carpentry in which the Moors displayed their magnificence. I visited the kitchens, the attics and the cellars – these were carved out of the rock, a few communicated with underground passages that seemed to pene-

trate deep into the mountain – but nowhere did I find anything to eat.

Finally, as daylight was completely fading, I went to fetch my horse, which I had tied up in the courtyard. I led it to a stable where I had seen a little hay, and I went to settle down for the night in a room where there was a pallet, the only one left in the whole inn. I would have very much liked to have a light, but the good thing about the hunger tormenting me was that it prevented me from sleeping.

However, the blacker the night became, the more sombre my thoughts. Some of the time I pondered on the disappearance of my two servants, and then on ways of obtaining food for myself. I thought that thieves, suddenly emerging from some bush or underground trap, had attacked Lopez and Mosquito, one after the other, when they were alone, and that I had been spared only because my military attire did not promise such an easy victory. My appetite preoccupied me more than anything else. But I had seen goats on the mountain; they must have been guarded by a goatherd, and this man must doubtless have some small supply of bread to eat with his milk. Moreover, I was relying somewhat on my gun. But to retrace my steps and expose myself to the caustic remarks of the landlord at Andujar – this I was determined not to do. I was on the contrary firmly resolved to continue my journey.

Having exhausted all such thoughts, I could not help calling to mind the famous story of the counterfeiters, and a few others of the like told to me when I was in the cradle. I also thought of the inscription on the collection-box. I did not believe that the devil had wrung the innkeeper's neck, but I understood nothing of his tragic end.

So the hours passed in profound silence, until the unexpected sound of a bell made me start in surprise. It chimed twelve times, and as everyone knows, ghosts have no power but from midnight until the first cockcrow. I say that I was surprised, and I had reason to be,

for the bell had not chimed the other hours. Moreover, it seemed to me there was something lugubrious about its ringing.

A moment later the bedroom door opened and I saw a figure come in that was completely black, but not frightening, for it was a beautiful negress; she was semi-naked and held a torch in each hand.

The negress came up to me, bowed low and said to me in very good Spanish: "Noble sir, some foreign ladies who are spending the night in this hostel invite you to share their supper. Be good enough to follow me."

I followed the negress along corridor after corridor, and finally into a well-lit room in the middle of which stood a table, laden with Japanese porcelain and carafes of rock crystal, and with three places set. At the far end of the room was a magnificent bed. Numerous negresses seemed eager to serve, but they stood by respectfully, and I saw two ladies enter the room, whose lily and rose colouring contrasted perfectly with the ebony complexion of their servants. The two ladies held each other by the hand. They were dressed in a bizarre style, or so at least it seemed to me, but the truth is this style is customary in many a town on the Barbary coast, from what I saw when I travelled there. Here, then, is what this costume comprised: it was really no more than a chemise and a corsage. The chemise was of linen to below the waist, but lower down it was of Meknes gauze, a kind of material that would have been completely transparent if wide silk ribbons, woven into the fabric, had not rendered it more apt to conceal such charms that gain by having to be guessed at. The corsage, richly embroidered with pearls and studded with diamonds, only just covered the bosom. It had no sleeves, whilst those of the chemise, also of gauze, were turned back and tied behind the neck. Their bare arms were adorned with bracelets, as many at the wrist as above the elbow. The feet of these ladies, which, had they been devils, would have been cloven, or equipped with claws, were nothing of the sort; they were

bare, in little embroidered mules, and the lower leg adorned with an anklet of large diamonds.

The two unknown women came towards me with an easy and gracious manner. They were both perfect beauties, one tall, svelte, dazzling, the other affecting and shy. The elder of the two had an admirable figure, and admirable too were her features. The younger one had a rounded figure, with lips a little pouting, eyelids half-closed, and the little of her eyes they revealed concealed by lashes of extraordinary length.

The eldest addressed me in Castilian, and said: "Noble sir, we thank you for your kindness in accepting this small collation, I believe you must be in need of it."

She said these last words with such an air of mischievousness that I almost suspected her of having arranged the abduction of the mule loaded with our provisions, but she was replacing them so well it was impossible to hold it against her.

We sat down at table, and passing me a porcelain bowl, the same lady said: "Noble sir, you will find here an *olla podrida*, composed of all kinds of meats, one only excepted, for we count ourselves among the Faithful, by which I mean Muslims."

"Beautiful stranger," I replied, "your choice of words seems apt. Doubtless you are faithful, such is the religion of love. But deign to satisfy my curiosity before my appetite: tell me who you are."

"There is no need to delay eating, noble sir," said the beautiful Moor, "we shall not conceal our identity from you of all people. My name is Emina, and my sister is called Zibedde. We live in Tunisia, but our family comes from Granada, and some of our relatives are still in Spain, where they secretly profess the faith of their fathers. Eight days ago, we left Tunisia. We put in to shore near Malaga, on a deserted beach. Then we travelled through the mountains between Loja and Antequera, then came to this lonely place to change our dress and to make all the arrangements necessary for our safety. So you see, noble

sir, our journey is a great secret that we have entrusted to your good faith."

I assured the beauties they needed to fear no indiscretion on my part, and then I started to eat, rather greedily to tell the truth, but yet with certain constrained graces, such as a young man gladly adopts when he finds himself alone of his sex in the company of women.

When my initial hunger was seen to have been appeased, and I was turning my attention to what are called in Spain *los dulces*, the lovely Emina commanded the negresses to show me how people danced in their country. It seemed that no command could be more agreeable to them. They obeyed with a liveliness that bordered on licence. I even believe that it would have been difficult to put a stop to their dancing, but I asked their beautiful mistresses whether they sometimes danced. By way of reply they simply rose and asked for castanets. The steps they danced resembled the *bolero* of Murcia and the *fofa* danced in the Algarve. Those who have been to these provinces will be able to form some idea of those steps, yet they will never understand all the charm brought to them by the natural gracefulness of the two African women, a charm heightened by the diaphanous robes in which they were clad.

I watched them for some time with a kind of sangfroid. Eventually, their movements quickened by a more lively cadence, the dizzying sound of the Moorish music, my spirits raised by the unexpected food – within me and without, all conspired to confuse my senses. I no longer knew whether I was with women or with insidious incubuses. I dared not see, I would not look. I placed my hand over my eyes, feeling faint.

The two sisters came up to me, each of them took me by the hand. Emina asked if I was unwell. I reassured her. Zibedde asked me what was the medallion she could see on my breast and whether it was the portrait of a mistress.

"It is", I told her, "a locket my mother gave me, and which I promised to wear always. It contains a fragment of the True Cross..."

At these words I saw Zibedde draw back and pale.

"You are troubled," I said to her, "yet the Cross can frighten none but the spirit of darkness."

Emina replied for her sister. "Noble sir," she said, "you know that we are Muslim and you ought not to be surprised at the distress my sister has revealed to you. I share it: we are very upset to see that you, our closest relative, are a Christian. These words amaze you, but was not your mother a Gomelez? We are of the same family, which is simply another branch of the Abencerrages family. But let us sit down on this sofa and I will tell you more."

The negresses withdrew. Emina placed me in the corner of the sofa and sat next to me, her legs crossed beneath her. Zibedde sat on the other side, resting on my cushion, and we were so close to each other that their breath mingled with mine.

Emina appeared to daydream for a moment, then looking at me with what seemed the keenest interest, she took my hand and said to me: "Dear Alphonse, there is no point in hiding it from you: it is not chance that has brought us here. We were waiting for you. If fear had made you take another road, you would have lost our respect for ever."

"You flatter me, Emina," I replied, "and I do not see what interest you can take in my worth."

"We take great interest in you," said the beautiful Moor, "but perhaps you will be less flattered by this when you know that you are the first man we have ever seen. What I say amazes you, and you seem to doubt it. I had promised you the story of our ancestors, but perhaps it would be better if I began with our own story."

The story of Emina and her sister Zibedde

We are daughters of Gasir Gomelez, maternal uncle of the now-reigning Dey of Tunis. We have never had a brother, nor have we ever seen our father, which means that, enclosed within the walls of the harem, we had no idea at all of your sex. However, since we were both born with an extreme propensity for affection, we loved each other with great passion. This attachment began in our earliest childhood. We would cry as soon as anyone tried to separate us, even momentarily. If one of us was scolded, the other would burst into tears. We would spend our days playing at the same table, and we would sleep in the same bed.

This intense love seemed to increase as we grew older, and it was further strengthened by an incident I am going to relate to you. I was then aged sixteen, and my sister fourteen. For a long time we had noticed books that my mother carefully hid from us. At first we paid little attention, being already extremely bored by the books from which we were taught to read. But with age came curiosity. We seized the moment when the forbidden cupboard was open and hastily removed a small volume, which turned out to be *The Love of Majnun and Leila*, translated from the Persian by Ben Omri. This divine work, which depicts in images of fire all the delights of love, set our young minds aflame. We could not understand it very well, because we had not seen any human beings of your sex, but we would repeat its expressions. We would speak the language of the lovers. Eventually we wanted to love each other as they did. I took the part of Majnun, my sister

that of Leila. At first I declared my passion for her through the arrangement of flowers, a kind of secret code in very common usage throughout Asia. Then I made my eyes speak, I prostrated myself before her, I kissed the path that she had trodden, I conjured the west winds to carry my loving suits to her, and I believed that with the fire of my sighs I stoked their breath.

Zibedde, true to the lessons of her author, granted me a meeting. I threw myself at her knees, I kissed her hands, I bathed her feet with my tears. My mistress first offered gentle resistance, then allowed me to steal a few favours from her, and at last she surrendered herself to my impatient ardour. In truth, our souls seemed to become one, and even now I know of nothing that could make us happier than we were then.

I do not know for how long we entertained ourselves with these impassioned scenes, but finally they gave way to more tranquil sentiments. We acquired a taste for the study of some sciences, especially for the knowledge of plants, which we studied in the writings of the celebrated Averroes.

My mother, who believed it impossible to arm oneself too much against the boredom of the harem, saw with pleasure that we liked to keep ourselves occupied. She summoned from Mecca a holy person called Hazereta, or the saint *par excellence*. Hazereta taught us the law of the Prophet. Her lessons were couched in that language of such purity and harmony which is spoken by the Koraish tribe. We could not tire of listening to her, and we knew by heart almost the whole of the Koran. Then my mother instructed us herself in the history of our family, and placed in our hands a great number of memoirs, some in Arabic, others in Spanish. Ah! my dear Alphonse, how odious your faith seemed to us from these books. How we hated your persecutory priests. But how great on the contrary was the interest we took in so many ill-fated illustrious men whose blood ran in our veins.

We would become enamoured now of Said Gomelez, who suffered martyrdom in the prisons of the Inquisition, now of his nephew Leiss, who for a long time led a primitive existence in the mountains, his life little different from that of wild animals. Such characters made us love men. We would have liked to see some, and often we would climb on to our terrace to discern in the distance the people embarking on the lake of La Goulette, or those going to the Hammam Nef baths. Whilst we had not completely forgotten the lessons of the amorous Majnun, at least we did not rehearse them together any more. I even thought that my love for my sister was no longer in the nature of a passion, but a fresh incident proved the contrary.

One day my mother brought to visit us a princess of Tafilelt, a middle-aged woman. We did our best to make her welcome. After she had left, my mother told me that she had asked for me in marriage on behalf of her son, and that my sister was to marry a Gomelez. This news came to us like a bolt from the blue. At first we were so taken aback by it, we lost the power of speech. Then the misery of living without each other impressed itself so forcefully upon us that we surrendered to the direst despair. We tore out our hair, we filled the harem with our cries. In short, the demonstrations of our grief exceeded all reason. My mother was terrified and promised not to force a husband on either of us. She assured us that we would be allowed to remain maidens, or to marry the same man. These assurances calmed us a little.

Some time afterwards my mother came to tell us that she had spoken to the head of our family, and that he had given leave for us to have the same husband, on condition he was a man of Gomelez blood.

We made no response at first, but this idea of sharing a husband appealed to us more every day. We had never seen a man, either young or old, except from a great distance, but since young women seemed to us more agreeable than old women, we wanted our husband to be

young. We hoped too that he would explain to us some of the passages from Ben Omri's book whose meaning we had not entirely grasped...

Here Zibedde interrupted her sister, and clasping me in her arms, she said: "My dear Alphonse, would that you were a Muslim! How happy I should be to see you in the arms of Emina, to add to your pleasures, to join your embraces. For after all, my dear Alphonse, in our house, as in the Prophet's, the sons of a daughter have the same rights as the male line. It may depend entirely on you to become the head of our family, which is about to die out. You have only only to open your eyes to the holy truths of our faith."

This seemed to me so strongly to resemble an insinuation of Satan that I believed I could already see horns on Zibedde's pretty forehead. I stammered out a few words of religion. The two sisters drew back a little.

Emina assumed a more serious expression and continued in these terms: "Signor Alphonse, I have spoken too much about my sister and myself. This was not my intention. I only sat down here to tell you the story of the Gomelez, of whom you are a descendant through the female line. Here then is what I have to say to you."

The story of the castle Cassar Gomelez

The original founder of our family was Massoud Ben Taher, brother of Youssouf Ben Taher, who led the

Arabs into Spain and gave his name to the mountain of Gebal-Taher, which you pronounce Gibraltar. Massoud, who had greatly contributed to their success in arms, obtained from the Caliph of Bagdad the governorship of Granada, where he remained until the death of his brother. He would have remained there longer, for he was cherished by the Muslims as well as the Mozarabs, that is to say, the Christians who had stayed under Arab rule; but Massoud had enemies in Bagdad, who denigrated him in the Caliph's mind. He knew that his downfall was inevitable, and took the decision to flee. So Massoud assembled his family and took refuge in the Alpujarras, which are, as you know, a continuation of the mountains of the Sierra Morena, and this chain separates the realm of Granada from that of Valencia.

The Visigoths, from whom we conquered Spain, had not penetrated the Alpujarras. Most of the valleys were desolate. Only three were inhabited, by descendants of an ancient people of Spain. They were called Turdules. They recognized neither Muhammad nor your Nazarene prophet. Their religious beliefs and their laws were contained in songs that fathers taught their children. They had books, which were lost.

Massoud subjugated the Turdules more by persuasion than by force. He learned their language and taught them the Muslim law. The two peoples were united through marriage; it is to this miscegenation and to the mountain air that we owe this high colouring, which you see in my sister and myself, and which distinguishes the daughters of the Gomelez. One sees among the Moors a great many very light-skinned women, but they are always pale in complexion.

Massoud took the title of Sheikh, and built a heavily fortified castle, which he called Cassar Gomelez. Judge rather than sovereign of his tribe, Massoud was at all times accessible, and made it his duty to be so, but on the last Friday of every month, he would take leave of his family, shut himself away in a cellar of the castle and

remain there until the following Friday. These disappearances gave rise to different conjectures: some said that our Sheikh had meetings with the twelfth imam, who is to appear on earth when the centuries come to an end. Others believed that the Antichrist was chained up in our cellar. Others thought that the Seven Sleepers lay there with their dog Caleb. Massoud took no notice of these rumours; he continued to govern his small people for as long as his strength allowed him. Eventually he chose the wisest man of the tribe, named him his successor, handed him the key to the cellar, and retired to a monastery, where he lived for many more years.

The new Sheikh governed as his predecessor had done, and made the same disappearances on the last Friday of every month. Everything continued as before, until Cordoba had its own caliphs, independent of those of Bagdad. Then the mountain-people of the Alpujarras, who had taken part in this revolution, began to settle on the plains, where they were known by the name of Abencerrages, whilst the name of Gomelez was kept by those who remained subjects of the Sheikh of Cassar Gomelez.

However, the Abencerrages bought the best land in the kingdom of Granada and the finest houses in town. Their wealth drew public attention; it was assumed that the Sheikh's cellar contained an immense treasure, but no one could confirm this because the Abencerrages themselves did not know the source of their wealth.

Finally these noble kingdoms, having brought upon themselves the vengeance of heaven, were delivered into the hands of the Infidels. Granada was taken, and eight days later the famous Gonzalo de Cordoba came into the Alpujarras at the head of three thousand men. Hatem Gomelez was then our Sheikh. He went out to meet Gonzalo and offered him the keys to his castle; the Spaniard asked him for the keys to the cellar. The Sheikh gave him these too, without any objection. Gonzalo wanted to go down into the cellar himself: he found there

only a tomb and some books. He openly decried all the tales he had been told and lost no time in returning to Valladolid, where love and chivalry called him.

Thereafter, peace reigned on our mountains, until Charles came to the throne. At that time our Sheikh was Sefi Gomelez. This man, for motives that have never been clear, informed the new emperor that he would reveal to him an important secret if he would send to the Alpujarras some lord in whom he trusted. Before the fortnight was out, Don Ruiz of Toledo presented himself to the Gomelez on behalf of His Majesty, but he found that the Sheikh had been murdered the previous day. Don Ruiz persecuted a few individuals, soon tired of the persecutions, and returned to Court.

However, the secret of the Sheikhs rested with Sefi's assassin. This man, whose name was Billah Gomelez, called together the elders of the tribe and convinced them of the need to take new precautions for the safeguarding of such an important secret. It was decided that several members of the Gomelez family would be told, but that each of them would be initiated to only a part of the mystery, and even so, only after having given dazzling proofs of courage, prudence and loyalty.

At this point Zibedde again interrupted her sister and said to her: "Dear Emina, do you not believe that Alphonse would have withstood all tests? Ah, who can doubt it? Dear Alphonse, if only you were Muslim! Immense treasures would perhaps be yours..."

This again was just like the spirit of darkness, who, having failed to lure me into temptation through sensual pleasure, was seeking to make me succumb through love of gold. But the two beauties drew closer, and it certainly seemed to me that I was touching bodies and not spirits.

After a moment's silence Emina resumed the thread of her story: "Dear Alphonse," she said to me, "you know well enough the persecution we suffered under the reign

of Philip, son of Charles. Our children were taken away from us and brought up in the Christian religion; these same children were given all that belonged to their parents, who had remained true to their faith. It was then that a certain Gomelez was admitted to the *teké* of the dervishes of St Dominic and reached the position of Grand Inquisitor..."

At this point we heard the cock crow, and Emina stopped talking... The cock crowed once more... A superstitious man might have expected the two fair ladies to fly up the chimney. They did not, but they seemed dreamy and preoccupied.

Emina was the first to break the silence. "Dear Alphonse," she said, "the day is about to dawn. The hours that are ours to spend together are too precious to devote to story-telling. We cannot be your wives unless you adopt our holy law. But it is permitted for you to see us in your dreams. Do you agree to this?"

I agreed to everything.

"That is not enough," said Emina with an air of the utmost dignity, "that is not enough, dear Alphonse. You must also vow on the sacred laws of honour never to betray our names, our existence, and everything you know about us. Dare you make that solemn oath?"

I promised all that was asked of me.

"That will do," said Emina. "Sister, bring the cup consecrated by Massoud, first head of our family."

While Zibedde went to fetch the enchanted vessel, Emina prostrated herself and recited prayers in the Arab tongue. Zibedde reappeared, holding a cup that looked as though it was carved out of single emerald. She put her lips to it. Emina did likewise, and ordered me to swallow the rest of the liquor in a single draught.

I obeyed.

Emina thanked me for my compliance and kissed me very tenderly. Then Zibedde pressed her mouth to mine and seemed unable to detach it. Eventually they left me,

saying that I would see them again, and they advised me to go to sleep as soon as possible.

So many bizzare events and marvellous stories and unexpected feelings would surely have been enough to keep me thinking all night, but it has to be admitted, the dreams I had been promised occupied my thoughts more than all the rest. I wasted no time in undressing and in getting into a bed that had been prepared for me. Once I was settled, I noted with pleasure that my bed was very wide and that dreams do not require so much room. But I had hardly enough time to entertain this thought before an irresistible sleep made my eyelids heavy, and all the deceptions of night at once took possession of my senses. I had the feeling of being disorientated by tricks of fancy, but my mind, carried on the wings of desire, set me in the heart of Africa's seraglios and seized upon the charms contained within those precincts to fashion my chimeric pleasures. I felt I was dreaming, and yet I was conscious of not embracing phantoms. I lost myself in the most wild illusions, but I always found myself again with my beautiful cousins. I fell asleep on their breasts, I awoke in their arms.

I do not know how many times I thought I experienced these sweet alternatives...

THE SECOND DAY

Eventually I really did awaken. The sun was burning my eyelids. I opened them with difficulty. I saw the sky. I saw that I was out in the open. But my eyes were still heavy with sleep. I was no longer sleeping, but I was not yet awake. A succession of images of torture passed through my mind. I was appalled by them. Jerked out of my slumber, I sat up...

How shall I find words to express the horror that seized me? I was lying under the gallows of Los Hermanos. The bodies of Zoto's two brothers were not strung up, they were lying by my side. I had apparently spend the night with them. I was lying on pieces of rope, bits of wheels, the remains of human carcases and on the dreadful shreds of flesh that had fallen away through decay.

I thought I was still not properly awake and was having a bad dream. I closed my eyes again and searched my memory, trying to recall where I had been the day before... Then I felt claws sinking into my sides. I saw that a vulture had settled on me and was devouring one of my bedmates. The pain of its grip awakened me fully. I saw that my clothes were by me, and I hurriedly put them on. When I was dressed, I tried to leave the gallows enclosure, but found the door nailed shut and made vain attempts to break it open. So I had to climb those grim walls. I succeeded in doing so, and clinging to one of the gallows posts, I began to survey the surrounding countryside. I easily got my bearings. I was actually at the entrance to the Los Hermanos valley, and not far from the banks of the Guadalquivir.

While I continued to look around, I saw two travellers near the river, one of whom was preparing a meal and the other holding the reins of two horses. I was so delighted to see these men that my first reaction was to call out to them, "*Agour, agour*", which means "Good-day", or "Greetings", in Spanish.

The two travellers, who saw the courtesies being extended to them from the top of the gallows, seemed undecided for a moment; but suddenly they mounted their horses, urged them to the fastest gallop, and took the road to Alcornoques.

I shouted at them to stop, to no avail. The more I shouted, the more they spurred on their mounts. When I lost sight of them, it occurred to me to quit my position. I jumped to the ground, hurting myself a little.

Hunched low and limping, I reached the banks of the Guadalquivir and found there the meal that the two travellers had abandoned. Nothing could have been more welcome, for I felt very exhausted. There was some chocolate that was still cooking, some *sponhao* steeped in Alicante wine, some bread and eggs. I set about restoring my strength, after which I began to reflect on what had happened to me during the night. My memories were very confused, but what I well recalled was having given my word of honour to keep it secret, and I was strongly resolved to abide by my promise. Once having decided on this, it only remained for me to consider what I needed to do for the moment – in other words, which road I should take – and it seemed to me that the laws of honour obliged me more than ever to go via the Sierra Morena.

People will perhaps be surprised to find me so concerned with my reputation, and so little concerned with the events of the previous day, but this way of thinking was again a result of the education I had received; this will be seen from the continuation of my story. For now, I return to the account of my journey.

I was extremely curious to know what the evil spirits had done with my horse, which I had left at Venta Quemada, and since in any case it was on my way, I determined to go by there. I had to walk the whole length of the Los Hermanos valley and that of the Venta, which did not fail to tire me and to make me greatly wish to find my horse. I did indeed find it; it was in the same stable where I had left it and seemed groomed, well cared for,

and well fed. I did not know who could have taken this trouble, but I had seen so many extraordinary things that this in addition did not for long detain me. I would have set off straight away, had I not had the curiosity to visit the inside of the tavern once more. I relocated the bedroom where I had slept, but no matter how hard I looked, I could not find the room where I had seen the beautiful African women. I tired then of looking for it any longer. I mounted my horse and continued on my way.

When I woke up under the Los Hermanos gallows, the sun was already half-way through its course. It took me two hours to reach the Venta. So when I had covered another couple of leagues, I had to think of a shelter for the night, but seeing none, I rode on. Eventually I saw in the distance a Gothic chapel, with a hut that appeared to be the home of hermit. All this was off the main road, but since I was beginning to feel hungry, I did not hesitate to make this detour in order to come by some food. When I arrived, I tied my horse to a tree. Then I knocked at the door of the hermitage and saw a monk with the most venerable face emerge from it. He embraced me with fatherly tenderness, then he said to me:

"Come in, my son. Quickly. Do not spend the night outside. Fear the temptor. The Lord had withdrawn his hand from above us."

I thanked the hermit for his goodness towards me, and I told him that I was in dire need of something to eat.

He replied: "O my son, think of your soul! Go to the chapel. Prostrate yourself before the Cross. I will see to the needs of your body. But you will have a frugal meal, such as one would expect from a hermit."

I went to the chapel and prayed sincerely, for I was not a freethinker and was even unaware there were any; this again was a result of my education.

The hermit came to fetch me after a quarter of an hour and led me to the hut, where I found a place laid for me (everything was reasonably clean). There were some excellent olives, chards preserved in vinegar, sweet onions

in a sauce, and rusks instead of bread. There was also a small bottle of wine. The hermit told me that he never drank any, but that he kept some in the house to celebrate the Mass. So I drank no more wine than the hermit, but the rest of the supper gave me great pleasure. While I was doing justice to it, I saw a figure, more terrifying than anything I had yet seen, come into the hut. It was a man. He looked young, but was hideously thin. His hair stood on end, one of his eyes was gouged out, and there was blood issuing from it. His tongue hung out of his mouth and dripped a frothy spittle. His body was clad in a fairly good black habit, but this was his only garment; he wore neither stockings nor shirt.

This hideous individual said not a word, and went and crouched in a corner, where he remained as still as a statue, his one eye fixed on a crucifix he held in his hand. When I had finished my meal, I asked the hermit who this man was.

The hermit replied: "My son, this man is possessed of the devil, and I am exorcising him. His terrible story is good evidence of the fatal power that the Angel of Darkness is usurping in this unhappy land. His experience might be helpful to your salvation, and I am going to instruct him to give an account of it."

Then, turning towards the possessed man, he said to him: "Pacheco, Pacheco, in the name of your Redeemer, I command you to tell your story."

Pacheco gave a horrible cry and began with these words:

The story of the demoniac Pacheco

I was born in Cordoba, where my father lived in more than comfortable circumstances. My mother died three years ago. My father seemed at first to miss her a great deal, but after a few months, having had occasion to make a trip to Seville, he fell in love with a young widow, called Camille de Tormes. This person did not enjoy a very good reputation, and several of my father's friends tried to stop him from seeing her, but despite the trouble they were prepared to go to, the wedding took place two years after the death of my mother. The ceremony took place in Seville, and a few days later my father returned to Cordoba with Camille, his new wife, and a sister of Camille, whose name was Inesille.

My new stepmother answered perfectly to the poor opinion in which she was held, and started out in my father's house by trying to win my love. She did not succeed in this. Yet I did fall in love, but with her sister Inesille. Indeed, my passion soon became so great that I went and threw myself at my father's feet and asked him for the hand of his sister-in-law.

With kindness, my father raised me to my feet, then said to me: "My son, I forbid you to think of this marriage, and I do so for three reasons. First, it would be unseemly for you to become, as it were, your father's brother-in-law. Secondly, the holy canons of the Church do not approve these kinds of marriages. Thirdly, I do not want you to marry Inesille."

Having given me his three reasons, my father turned his back on me and left.

I retired to my bedroom, where I gave way to despair. My stepmother, whom my father immediately informed

of what had happened, came to find me and told me I was wrong to torture myself; that if I could not become Inesille's husband, I could be her *cortejo*, that is to say, her lover, and that she would see to it; but at the same time, she declared her love for me and made much of the sacrifice she was making by yielding me to her sister. I listened only too avidly to these words that flattered my passion, but Inesille was so modest it seemed to me impossible that she could ever be persuaded to respond to my love.

Meanwhile, my father decided to journey to Madrid, with the intention of securing the post of *corregidor* of Cordoba, and he took with him his wife and sister-in-law. He was to be away for no more than two months, but this time seemed very long to me, because I was separated from Inesille.

When the two months were almost over, I received a letter from my father, in which he instructed me to go to meet him and wait for him at Venta Quemada, where the Sierra Morena began. It would have been no easy decision to travel by way of the Sierra Morena a few weeks earlier, but as it happened, Zoto's two brothers had just been hanged. His gang was disbanded and the roads were supposed to be fairly safe.

So I set out for Cordoba at about ten o'clock in the morning, and I spent the night at Andujar, where the landlord was one of the most talkative in Andalusia. I ordered a lavish supper at the inn, of which I ate some and kept the rest for my journey.

The next day I dined at Los Alcornoques on what I had saved from the day before, and that same evening I reached Venta Quemada. I did not find my father there, but as he had instructed me in his letter to wait for him, I determined to do so, all the more willingly since I was in a roomy and comfortable hostel. The innkeeper who ran it at that time was a certain Gonzalez of Murcia, quite a decent fellow although a big-talker, who, sure enough, promised me a supper worthy of a Spanish grandee.

While he busied himself preparing it, I went for a stroll along the banks of the Guadalquivir, and when I returned to the hostel, there I found a supper that was indeed not at all bad.

When I had eaten, I told Gonzalez to make up my bed. Then I saw that he was flustered: he said things that did not make a great deal of sense. Finally he confessed that the inn was haunted by ghosts, that he and his family spent every night at a small farm on the banks of the river, and he added that if I wanted to sleep there too, he would have a bed made up for me next to his own.

This proposal seemed to me quite unwarranted. I told him that he could go to sleep wherever he wanted to, and that he should send my men to me. Gonzalez obeyed, and withdrew, shaking his head and shrugging his shoulders.

My servants arrived a moment later. They too had heard talk of ghosts and tried to urge me to spend the night at the farm. Responding to their advice rather churlishly, I ordered them to make up my bed in the very room where I had supped. They obeyed me, albeit reluctantly, and when the bed was made, again they beseeched me, with tears in their eyes. Genuinely irritated by their admonitions, I allowed myself a display of emotion that put them to flight, and since it was not my custom to have my servants undress me, I easily managed without them in getting ready for bed. However, they had been more thoughtful than my behaviour towards them merited: by my bed, they had left a lighted candle, an extra candle, two pistols and a few books to read to keep myself awake; but the truth is I was no longer sleepy.

I spent a couple hours alternately reading and tossing in my bed. Eventually I heard the sound of a bell or a clock striking midnight. I was surprised, because I had not heard the other hours strike. Soon the door opened, and I saw my stepmother enter. She was in her nightgown and held a candlestick in her hand. She tiptoed over to me with her finger on her lips, as though to impose silence upon me. Then she rested her candlestick on my bedside table,

sat down on my bed, took one of my hands and spoke to me in these words:

"My dear Alphonse, the time has come when I can give you the pleasures I promised you. We arrived at this tavern an hour ago. Your father has gone to sleep at the farm, but since I knew that you were here, I obtained leave to spend the night here with my sister Inesille. She is waiting for you, and preparing herself to refuse you nothing. But I must inform you of the conditions I have laid on your happiness. You love Inesille, and I love you. I am willing to bring you together, but I cannot bring myself to leave you alone with each other. I shall share your bed. Come!"

My stepmother gave me no time to reply. She took me by the hand and led me along corridor after corridor, until we reached a door where she set about looking through the keyhole.

When she had looked long enough, she said to me; "Everything is going well, see for yourself."

I took her place at the keyhole, and there indeed was the lovely Inesille in her bed, but she was far from showing the modesty I had always seen in her. The expression in her eyes, her agitated breathing, her flushed complexion, her posture – everything about her was clear evidence she was awaiting a lover.

After letting me have a good look, Camille said to me: "My dear Pacheco, stay at this door. When the time is right, I shall come to let you know."

When she had gone in, I put my eye to the keyhole again and saw a thousand things I find hard to describe. First, Camille undressed with some deliberation, then getting into bed with her sister, she said to her:

"My poor Inesille, is it really true that you want to have a lover? Poor child, you do not know how he will hurt you. First he will flatten you, press himself upon you, and then he will crush you, tear you."

48

When Camille considered her pupil sufficiently indoctrinated, she came and opened the door to me, led me to her sister's bed, and lay down beside us.

What shall I say of that fateful night? I exhausted its pleasures and crimes. For a long time I fought against sleep and nature, the more to protract my diabolical gratification. At last I fell asleep, and I awoke the next day beneath the gallows on which Zoto's brothers were hanged, lying between their vile corpses.

Here the hermit interrupted the demoniac and said to me: "Well now, my son! What do you think of that? I believe you would have been very frightened to find yourself lying between two hanged men?"

I replied: "Father, you insult me. A gentleman must never be afraid, and still less when he has the honour of being a captain in the Walloon Guards."

"But my son," said the hermit, "have you ever heard tell of such an adventure befalling anybody?"

I hesitated for a moment, after which I replied: "Father, if this adventure befell Signor Pacheco, it might have befallen others. I will be better able to judge if you would kindly tell him to continue his story."

The hermit turned to the demoniac, and said to him: "Pacheco, Pacheco! In the name of your Redeemer, I order you to continue your story."

Pacheco uttered a dreadful howl and continued in these words:

I was half dead when I left the gibbet. I dragged myself off without knowing where I was going. At last I met some travellers who took pity on me and brought me back to Venta Quemada. There I found the innkeeper and my servants, who were greatly worried about me. I asked them if my father had slept at the farm. They replied that no one had come.

I could not bear to stay any longer at the Venta, and I set out again on the road to Andujar. I did not arrive there until after sunset. The inn was full, a bed was made up for me in the kitchen, and I lay down in it. But I was unable to sleep, for I could not banish from my mind the horrors of the night before.

I had left a lighted candle on the kitchen hearth. Suddenly it went out, and at once I felt what seemed a deathly shudder that made my blood run cold.

Someone pulled off my blanket. Then I heard a little voice saying: "It is Camille, your stepmother, I am cold, dear heart. Make room for me under your blanket."

Then another little voice said: "And this is Inesille. Let me get into your bed. I am cold, I am cold."

Then I felt an icy hand take hold of my chin. I summoned up all my strength to say out loud: "Avaunt, Satan!"

Then the little voices said to me: "Why are you chasing us away? Are you not our darling husband? We are cold. We are going to make a little fire."

Sure enough, soon after I saw flames in the kitchen hearth. The flames became brighter and I saw not Inesille and Camille but Zoto's two brothers, hanging in the fireplace.

This sight scared the life out of me. I leapt out of bed. I jumped through the window and started to run through the countryside. For a moment I was able to cherish the fond belief that I had escaped these horrors; but I turned round and saw that I was being followed by the two hanged men. I started to run again, and I saw that the hanged men were left behind. But my joy was short-lived. These detestable creatures began to cartwheel and in an instant were upon me. I ran on, until finally my strength deserted me.

Then I felt one of the hanged men seize me by the heel of my left foot. I tried to shake him off, but his brother cut in front of me. He appeared before me, rolling his eyes dreadfully, and sticking out a tongue as red as an iron

drawn from the fire. I begged for mercy; in vain. With one hand he grabbed me by the throat, and with the other he tore out the eye I am now missing. In the place where my eye had been, he stuck his burning-hot tongue. With it he licked my brain and made me howl with pain.

Then the other hanged man, who had seized my left leg, also wanted to leave his mark on me. First he began by tickling the sole of the foot he was holding. Then the monster tore the skin off it, separated all the nerves, bared them, and set to playing on them as though on a musical instrument; but since I did not render a sound that pleased him, he began to twist them, as one tunes a harp. Finally he began to play on my leg, of which he had fashioned a psaltery. I heard his diabolical laughter; while pain wrung dreadful howls out of me, the wailings of hell joined voice. But when it came to my hearing the damned gnashing their teeth, I felt as though they were grinding my every fibre. In the end I lost consciousness.

The next day shepherds found me in the countryside and brought me to this hermitage, where I have confessed all my sins and here at the foot of the Cross I have found some relief from my ills.

At this point the demoniac uttered a dreadful howl and fell silent.

Then the hermit spoke and said to me: "Young man, you see the power of Satan, pray and weep. But it is late. We must part company. I do not propose that you sleep in my cell, for Pacheco's screams during the night might disturb you. Go and sleep in the chapel. There you will be under the protection of the Cross, which triumphs over evil spirits.

I told the hermit I would sleep wherever he wanted me to. We carried a little trestle bed to the chapel. I lay down on it and the hermit wished me good-night.

When I was alone, Pacheco's story came back to me. I found in it a great deal of similarity with my own adventures, and I was still reflecting on it when I heard the

chimes of midnight. I did not know whether it was the hermit ringing the bell, or whether I was again dealing with ghosts. Then I heard a scratching at my door. I went to the door and asked: "Who goes there?"

A little voice answered: "We are cold, open up and let us in, it is your darling wives here."

"Yes, yes, of course, you damnable gallows' fodder," I replied, "return to your gibbet and let me sleep."

Then the little voice said: "You jeer at us because you are inside a chapel, but come outside a while."

"I am just coming," I instantly replied.

I went to fetch my sword and tried to get out, but found the door locked. I told the ghosts, who made no response. I went to bed and slept until it was light.

THE THIRD DAY

I was awakened by the hermit, who seemed very pleased to find me safe and sound. He embraced me, bathed my cheeks with his tears, and said:

"My son, strange things happened last night. Tell me the truth: did you spend the night at Venta Quemada? Did the demons take possession of you? There is still a remedy. Come to the foot of the altar. Confess your sins. Do penance."

The hermit was full of suchlike exhortations. Then he fell silent, awaiting my reply.

So I said to him: "Father, I made my confession before leaving Cadiz. Since then, I do not believe I have committed any mortal sin, except perhaps in thought. It is true that I spent the night at Venta Quemada. But if I saw anything there, I have good reason not to speak of it."

This reply seemed to surprise the hermit. He accused me of being possessed of the devil of pride and tried to persuade me that I needed to make a full confession. But seeing that my obstinacy was unassailable, he somewhat dropped his priestly tone and adopting a more natural manner said to me:

"My child, your courage astonishes me. Tell me who you are. What education you have received. And whether you believe in ghosts, or not. Do not refuse to satisfy my curiosity."

I replied: "Father, the desire you show to become acquainted with me can only do me honour, and I am duly obliged to you. Allow me to get up. I will come and find you at the hermitage, where I tell you everything you want to know about me."

The hermit embraced me again, and withdrew.

When I was dressed, I went to find him. He was heating some goat's milk, which he gave me with some sugar and some bread. He himself ate a few roots boiled in water.

When we had finished our meal, the hermit turned to the demoniac and said to him:

"Pacheco! Pacheco! In the name of your Redeemer, I order you to go and take my goats on to the mountain."

Pacheco uttered a dreadful howl and left us.

Then I began my story, which I told him in these words:

The story of Alphonse van Worden

I was born of a very old family, albeit one that has enjoyed but little distinction and yet scantier wealth. Our whole patrimony has only ever consisted of a noble fief, called Worden, this land being part of the Burgundy estates and situated in the middle of the Ardennes.

Having an older brother, my father had to content himself with a very meagre inheritance, which nevertheless sufficed to support him honourably in the army. He fought the entire War of Succession, and when peace came, King Philip V conferred on him the rank of lieutenant-colonel in the Walloon Guards.

There prevailed in the Spanish army, at that time, a certain code of honour, carried to the most excessive degree of refinement, and my father excelled even in this excess. And truly one cannot blame him, since honour is properly the life and soul of a soldier. Not a duel took place in Madrid upon whose niceties my father did not rule; and as soon as he said that reparations were adequate, everyone considered himself satisfied. If by chance

anyone did not appear happy with the ruling, he straight-away had my father to contend with, who would not fail to uphold at sword-point the merit of each of his decisions. Furthermore, my father had a white book, in which he wrote down an account of each duel and all the circumstances, which really stood him in good stead, enabling him to pronounce with justice on all ticklish cases.

Almost solely occupied by his court of retribution, my father had shown himself little sensitive to the charms of love, but eventually his heart was smitten by the attractions of an unmarried lady, who was still quite young, called Urraque de Gomelez, daughter of the *oidor* of Granada, of the same lineage as the former kings of the country. Mutual friends soon brought together the interested parties, and the marriage was concluded.

My father deemed it fitting to invite to his wedding all the people with whom he had fought – that is, those he had not killed. They were 122 at table, with thirteen from Madrid who did not come, and thirty-three with whom he had fought in the army, of whom he had no news. My mother often told me that this feast was extraordinarily jolly, and that the greatest cordiality had reigned over it, which I had no difficulty in believing, for my father was, at bottom, exceptionally good-hearted and greatly loved by everyone.

For his own part, my father was very attached to Spain, and he would never have left it, but two months after his marriage, he received a letter signed by the magistrate of the town of Bouillon. The letter informed him that his brother had died childless, and that the fief had fallen to him. This news threw my father into the greatest confusion, and my mother told me that he was then so preoccupied that not a word could be drawn from him. Finally he opened his chronicle of duels, chose the twelve men of Madrid who had fought the greatest number, invited them to come to his house, and addressed them in these words:

"My dear brothers-in-arms, you know well enough how many times I have set your consciences at rest in cases where honour seemed compromised. Today I find myself obliged to rely on your wisdom, because I fear my own judgement fails me; or rather, I fear it is clouded by some sense of partiality. Here is the letter written to me by the magistrates of Bouillon, whose testimony is worthy of respect, though they are not gentlemen. Tell me if honour obliges me to dwell in my fathers' castle, or if I ought to continue to serve King Don Philip, who has showered me with favours, and has recently raised me to the rank of brigadier-general. I am leaving the letter on the table and going away. I shall return in half and hour to learn what you have decided."

Having said this, my father duly left the room. He came back after half an hour and took the vote. There proved to be five in favour of his remaining a serving officer, and seven in favour of his going to live in the Ardennes. My father without demur accepted the advice of the majority.

My mother would very much have liked to stay in Spain, but she was so devoted to her husband that he had not the slightest inkling of her reluctance to leave her country. Eventually there was no thought but for preparations for the journey, and for those few individuals who were to make it, as representatives of Spain in the middle of the Ardennes. Although I was not yet born into this world, my father, who did not doubt my coming, thought it time to provide me with a master-at-arms. His choice fell on Garcias Hierro, the best assistant fencing master in Madrid. Tired of parrying thrusts every day at Place de la Cebada, this young man readily made up his mind to come. My mother, for her part, not wanting to leave without a chaplain, chose the theologian Inigo Velez, a graduate of Cuenca. He was also to instruct me in the Catholic religion and the Castilian language. All these arrangements for my education were made a year and a half before my birth.

When my father was ready to depart, he went to take his leave of the King and, in accordance with the custom at the Court of Spain, he went down on one knee to kiss his sovereign's hand. But as he did so, his heart was so constricted with emotion that he fainted and had to be carried home. The next day he went to take leave of Don Fernand de Lara, who was then Prime Minister. This nobleman received him with extraordinary distinction and informed him that the King had granted him a pension of twelve thousand *reales*, with the rank of *sargente general*, which is equivalent to that of brigadier. My father would have given some measure of his own blood for the satisfaction of throwing himself yet once more at his master's feet, but since he had already taken his leave, he contented himself with expressing in a letter some of the feelings with which his heart was filled. At last he left Madrid, shedding many a tear.

My father chose the road through Catalonia so as to set eyes once more on the places where he had served in war and to take leave of several of his former comrades who had commands on this frontier. Then he entered France via Perpignan.

His journey as far as Lyons was clouded by no untoward event; but as he left this town with post horses, he was overtaken by a chaise which, being lighter, reached the post house first. My father, who arrived a moment later, saw that horses were already being harnessed to the chaise. He at once took up his sword, and approaching the traveller, asked if he might speak to him for a moment in private. Seeing that my father wore the uniform of a general officer, the traveller, who was a French colonel, also took up his sword to do him honour. They went into an inn that stood opposite the post house and asked for a room.

When they were alone, my father said to the other traveller: "Good sir, your chaise overtook my coach so as to reach the post house before me. This in itself is no

insult, nevertheless there is something disobliging about it, for which I believe I must demand satisfaction of you."

Very surprised, the colonel laid all blame on the postilions, and assured my father there was no offence on his part.

"Good sir," said my father, "neither do I wish to make a serious issue of this, and I shall settle for duelling until blood is drawn." As he spoke, he drew his sword.

"Just a moment," said the Frenchman. "As I see it, it was not that my postilions overtook yours, but that yours, by going more slowly, lagged behind."

My father gave this some thought, then said to the colonel: "Good sir, I believe you are right, and had you pointed this out to me sooner, before I had drawn my sword, I think we would not have duelled. But surely you see that as matters stand we must have a little blood."

The colonel, who doubtless found this last reason good enough, took his guard. It was not a lengthy duel. Aware that he had been injured, my father immediately lowered the point of his sword and offered fulsome apologies to the colonel for the trouble he had caused him. The latter responded by offering his services, gave the address where he could be found in Paris, climbed back into his chaise and departed.

My father at first thought his injury to be very slight, but he was so covered with previous injuries that a new cut could scarce but fall on an old scar. The colonel's sword-thrust had indeed reopened an old musket-wound, in which the bullet had remained lodged. The leadshot made new efforts to come to the surface, finally emerged after two months' dressing of the wound, and the journey was resumed.

On his arrival in Paris, my father's first concern was to pay his respects to the colonel, whose name was the Marquis d'Urfé. He was one of the courtiers held in the highest esteem. He received my father with the utmost courtesy, and offered to give him an introduction to the minister, as well as to the best circles. My father thanked

him and asked only to be presented to the Duc de Tavannes, then the most senior marshal, because he wanted to be informed of everything regarding the Court of Honour, of which he had always entertained the most lofty ideas, often speaking of it in Spain as a very wise institution, one he would have much liked to see introduced in the realm. The marshal received my father with great politeness and commended him to the Chevalier de Bélièvre, first officer of the Lords Marshals, and reporter of their court.

Since the Chevalier came often to my father's house, he became aware of his chronicle of duels. This work seemed to him unique of its kind, and he asked permission to show it to the Lords Marshals, whose assessment of it concurred with that of their first officer. They sent a request to my father for the favour of a copy, which would be kept in the record office of their court. No proposition could have been more flattering to my father, and he derived from it an inexpressible joy.

Similar marks of respect rendered their stay in Paris very agreeable to my father, but my mother took a different view of it. She had made a point not only of not learning French but of not even listening when anyone spoke this language. Her confessor, Inigo Velez, was constantly making bitter jests about the libertinism of the Gallic Church, and Garcias Hierro concluded all conversations with the verdict that the French were miserable worms.

At last they left Paris. Four days later they arrived in Bouillon. My father made himself known to the magistrate and went to take possession of his fief.

Bereft of the presence of its masters, the ancestral home had also suffered the loss of some of its rooftiles – so much so that it rained as heavily in the bedrooms as it did in the courtyard, only the paving-stones in the courtyard dried very quickly, whereas the water had formed puddles in the bedrooms that never dried. This domestic flooding did not displease my father because it reminded him of the

siege of Lerida, where he had spent three weeks with his legs in water.

However, his first concern was to put his wife's bed in a dry place. There was in the reception room a Flemish-style fireplace, around which fifteen people could comfortably warm themselves. The mantel formed a kind of roof over it, supported by two columns on either side. The chimney-flue was blocked off so that my mother's bed could be placed under the mantel, with her bedside table and a chair; and since the hearth was raised a foot above ground-level, it formed a kind of island that was fairly inaccessible.

My father installed himself on the other side of the room, on two tables joined together with planks, and from his bed to my mother's a jetty was erected, fortified in the middle by a kind of bulwark constructed of chests and packing-cases. This work was completed on the day of our arrival at the castle, and I came into the world nine months later to the day.

While work on the most urgent repairs was carried out with great dispatch, my father received a letter which filled him with joy. It was signed by the Maréchal de Tavannes, and this nobleman sought his opinion on a matter of honour which was then engaging the court's attention. This genuine mark of consideration seemed to my father of such consequence that he wanted to celebrate it by fêting the whole neighbourhood. But we had no neighbours, so the festivities were confined to a fandango performed by the master-at-arms and Signora Frasca, my mother's first chambermaid.

My father, in reply to the marshal's letter, asked if he would be so kind as to send him in due course a summary of the court's proceedings. This favour was granted to him, and on the first of every month he would receive a letter that fuelled conversation and small talk for more than four weeks, during winter evenings round the big fireplace, and during the summer on two benches that stood before the castle entrance.

Throughout my mother's pregnancy, my father constantly spoke to her of the son she would have, and he thought of giving me a godfather. My mother favoured the Maréchal de Tavannes or the Marquis d'Urfé. My father agreed this would be a great honour for us, but he feared that these two noble lords might think it too great an honour, and with well-judged discretion he decided upon the Chevalier de Bélièvre, who, for his part, respectfully and gratefully consented.

At last I came into the world. At three years of age I was already holding a foil, and at six I could fire a pistol without blinking... I was about seven when we received a visit from my godfather. This gentleman had married in Tournai, and there he held the office of lieutenant in the King's Household and reporter in the Court of Honour. These are positions whose origins go back to the time of trial by champions and later they were brought together under the authority of the Court of the Marshals of France.

Madame de Bélièvre was of very delicate health, and her husband was taking her to the waters at Spa. Both of them became extremely fond of me, and since they had no children of their own they begged my father to entrust them with my education, which, in any case, could not have been properly attended to in a region as remote as that where the Worden castle stood. My father agreed, persuaded above all by the office of reporter of the Court of Honour, which held out the promise that in the Bélièvre household I was sure to be steeped from an early age in all the principles that ought one day to determine my conduct.

At first there was talk of my being accompanied by Garcias Hierro, because my father believed the noblest style of fighting was with sword in the right hand and dagger in the left, a type of fencing completely unknown in France. But since my father had adopted the habit of fencing on the battlements every morning with Hierro,

and this exercise had become essential to his well-being, he did not think he ought to deprive himself of it.

There was also talk of sending the theologian Inigo Velez with me, but since my mother still spoke only Spanish, it was quite natural that she should not be able to spare a confessor who knew this language. So it was that I did not have at my side the two men who, before my birth, had been destined to educate me. However, I was given a Spanish manservant, with whom I could practise speaking Spanish.

I set off for Spa with my godfather. We spent two months there. We made a trip to Holland and arrived in Tournai towards the end of autumn. The Chevalier de Bélièvre proved wholly equal to the trust my father had placed in him and for six years he neglected nothing that could contribute to make of me one day an excellent officer. At the end of that time, it happened that Madame Bélièvre died, her husband left Flanders to settle in Paris, and I was summoned back to the paternal home.

After a journey that the lateness of the season made rather difficult, I arrived at the castle some two hours after sunset, and found the inhabitants gathered around the big fireplace. My father, although pleased to see me, did not give way to any demonstration of feeling that might have compromised what you Spaniards call *gravedad*. My mother bathed me with tears. The theologian Inigo Velez gave me his blessing, and the swordsman Hierro presented me with a foil. We fought a bout in which I defended myself in a manner in advance of my years. My father was too expert not to notice, and his seriousness gave way to the most lively affection. Supper was served and everyone was very jolly.

After supper we all resumed our seats round the hearth, and my father said to the theologian: "Reverend Don Inigo, would you be good enough to fetch that big book of yours in which there are so many marvellous stories, and read us one."

The theologian went up to his room and came back with a folio bound in white parchment yellowed by time. He opened it at random and read out from it what follows:

The story of Trivulce of Ravenna

Once upon a time, in a town in Italy called Ravenna, there was a young man called Trivulce. He was handsome, rich and had a very high opinion of himself. The young girls of Ravenna would come to their windows to see him pass by, but none was to his liking. Or if he sometimes took a slight fancy to one or other of them, he did not show her any favour, for fear of doing her too much honour. In the end, all this pride could not withstand the charms of the young and beautiful Nina dei Gieraci. Trivulce deigned to declare his love to her. Nina replied that Lord Trivulce did her great honour, but that since childhood she had loved her cousin Tebaldo dei Gieraci, and that she would surely never love any other but him.

At this unexpected reply Trivulce departed, showing signs of the utmost rage.

A week later, which was a Sunday, as all the citizens of Ravenna were making their way to St Peter's Cathedral, Trivulce spotted Tebaldo in the crowd, giving his arm to his cousin. He covered his face with his cloak and followed them. Once inside the church, where it is not permitted to hide one's face in one's cloak, the two lovers could easily have seen that Trivulce was following them,

but they were solely engrossed in their love, to which they gave more thought than to the Mass.

Meanwhile, Trivulce had seated himself on a pew behind them. He heard everything they said, fuelling his rage with their words. Then a priest climbed into the pulpit and said: "My brothers, I am here to publish the banns for Tebaldo and Nina dei Gieraci; does anyone oppose their marriage?"

"I oppose it!" cried Trivulce, and at the same time he stabbed the two lovers twenty times. People tried to stop him, but he delivered more stab-wounds, left the church, then the town, and made his way to the State of Venice.

Trivulce was arrogant, spoiled by wealth, but he had a sensitive soul. Remorse avenged his victims, and he dragged out a lamentable existence from town to town. After a few years his parents settled matters for him, and he returned to Ravenna; but he was no longer the same Trivulce, beaming with happiness and proud of his advantages. He was so changed, not even his nurse recognized him.

On the first day of his return Trivulce asked where Nina's tomb was. He was told she was buried with her cousin in the church of St Peter, close to where they had been murdered. Trembling as he went, Trivulce came to the tomb, whereupon he kissed it and shed many tears.

Whatever grief the unhappy murderer suffered at that moment, he felt his tears had brought him relief. This is why he gave his purse to the sacristan and obtained leave to enter the church whenever he wanted. So it was that he decided to come there every evening, and the sacristan, having grown accustomed to this, paid little attention to him.

One evening Trivulce, who had not slept the night before, fell asleep at the tomb, and when he awoke he found that the church was locked. He readily resolved to spend the night there, because he liked to foster his sadness and nurture his melancholy. Hour after hour, he

heard the clock strike, and he wished he had come to the hour of his death.

Eventually midnight struck. Then the door to sacristy opened and Trivulce saw the sacristan enter, carrying his lantern in one hand and a broom in the other. But this sacristan was but a skeleton. He had a little skin on his face and what looked like deeply sunken eyes; but the surplice that clung to his bones revealed clearly enough that he had no flesh at all.

The ghastly sacristan placed his lantern on the high altar and lit the candles as though for vespers. Then he began to sweep the church and to dust the pews. Several times he even passed close to Trivulce, but seemed not to see him.

Finally he went to the door of the sacristy and rang the little bell that always hangs there. Then the tombs opened, the dead appeared wrapped in their shrouds and started singing litanies in very melancholy tones.

After they had chanted in this manner for some time, one of the dead, dressed in a surplice and stole, climbed into the pulpit and said: "My brothers, I am here to publish the banns of Tebaldo and Nina dei Gieraci. Damned Trivulce, do you oppose them?"

My father interrupted the theologian at this point, and turning to me, he said: "My son Alphonse, in Trivulce's position, would you have been afraid?"

I replied: "My dear father, I think I would have been terrified."

Then my father rose in a fury, seized his sword and would have run me through with it had someone not intervened. Eventually he was calmed down a little.

However, when he had resumed his seat, he shot a terrible glance at me and said: "Unworthy son of mine, your cowardice in somewise dishonours the Walloon Guards regiment I had intended you to join."

After these harsh reproaches, which almost caused me to die of shame, a great silence fell. Garcias was the first to break it, and addressing my father, he said:

"My lord, if I were to make so bold as to offer Your Excellency my advice, it would be to prove to your dear son that there are no ghosts, or spectres, or dead men that sing litanies, and that there cannot be any. In this way, he would surely not be afraid of them."

"Signor Hierro," replied my father a little sharply, "you forget that yesterday I had the honour of showing you a story about ghosts written in my great-grandfather's very own hand."

"My lord," said Garcias, "I do not give the lie to Your Excellency's great-grandfather."

"What do you mean by 'I do not give the lie'?" said my father. "Are you aware that this expression presupposes the possibility of your contradicting my great-grandfather?"

"My lord," said Garcias, "I am well aware that I am of too little account that his lordship your grandfather should want to demand any satisfaction of me."

Then adopting an even more fearsome look, my father said: "Hierro, may heaven keep you from presenting apologies, for they would presuppose some offence."

"Well," said Garcias, "it only remains for me to submit myself to the punishment it pleases Your Excellency to inflict upon me in the name of your great-grandfather, but for the honour of my profession, I should like this penalty to be administered to me by our chaplain, so that I may consider it an ecclesiastical penance."

"That is not a bad idea," my father said then, in a calmer tone of voice. "I recall having once written a small treatise on the forms of satisfaction acceptable in cases where the duel could not take place. Let me think about it."

My father seemed at first to be applying his mind to the subject, but as one thought led to another, he eventually fell asleep in his armchair. My mother was already asleep, so too was the theologian, and Garcias was not long in

66

following their example. I thought then I ought to leave them, and so passed the first day of my return to the paternal home.

The next day I fenced with Garcias. I went hunting. We ate supper, and when we rose from the table, my father again asked the theologian to fetch his big book. The priest obeyed, opened it at random, and read what I am about to tell you:

The story of Landulphe of Ferrara

In a town in Italy called Ferrara, there was a young man called Landulphe. He was a faithless libertine and detested by all good souls from thereabouts. This wicked fellow was passionately fond of frequenting whores, and he had gone the rounds of all those in town, but none pleased him as much as Bianca de Rossi, because she surpassed all the others in immorality.

Bianca was not only licentious, self-seeking, depraved, but she also wanted her lovers to perform for her deeds that brought them dishonour, and she demanded of Landulphe that he should take her home with him every evening to dine with his mother and sister. Landulphe immediately went to his mother and put this proposal to her, as though it were the most respectable thing in the world. His good mother burst into tears and beseeched her son to consider his sister's reputation. Landulphe was deaf to her pleas and promised only to keep the matter as

secret as he could. Then he went to fetch Bianca and brought her to the house.

Landulphe's mother and sister made the prostitute more welcome than she deserved. But seeing their goodness, Bianca became twice as brazen. She made some very suggestive remarks at supper, and gave her lover's sister lessons she would gladly have done without. Finally Bianca made it clear to the sister, and to her mother, that they would do well to leave the room, because she wanted to be alone with Landulphe.

The next day the prostitute told this story all over town, and for several days the talk was of nothing else. So much so that the much-bruited gossip soon came to the ears of Odoardo Zampi, brother of Landulphe's mother. Odoardo was a man no one insulted with impunity. Considering himself to have been insulted in his sister's person, he had the infamous Bianca killed that very day. Landulphe, who had gone to see his mistress, found her stabbed and swimming in her own blood. He soon learned it was his uncle who was responsible. He ran to his uncle's house to punish him, but found the place surrounded by the boldest fellows in town, who jeered at his resentment.

Not knowing on whom to vent his fury, Landulphe ran to his mother's house with the intention of heaping insults upon her. The poor woman was with her daughter and about to sit down to eat. When she saw her son enter the house, she asked him if Bianca would be coming to supper.

"Would that she came," said Landulphe, "and took you to hell, together with your brother and the whole Zampi family of yours."

His poor mother fell down on her knees and said: "O my God! Forgive him his blasphemy."

At that moment the door crashed open, and they saw a gaunt spectre come in, slashed with stab-wounds and yet retaining a dreadful resemblance to Bianca.

Landulphe's mother and sister began to pray, and by God's grace they were able to endure this spectacle without dying of fright.

The apparition slowly advanced and sat down at table as though to have supper. With a courage the devil alone could have inspired, Landulphe dared to pick up a platter and offer it to the ghost, which opened a mouth so large that its head seemed to split in two, and a reddish flame came out. Then the ghost stretched out a hand that was all burned, took a morsel and swallowed it; the food could be heard falling under the table. When the platter was empty, the ghost fixed Landulphe with its terrible eyes and said:

"Landulphe, when I have supper here, I stay the night. Now, get into bed!"

At this point my father interrupted the chaplain, and turning to me, said: "My son Alphonse, in Landulphe's position, would you have been afraid?"

I replied: "My dear father, I assure you that I would not have felt the slightest fear."

My father seemed satisfied with this reply and was very jolly for the rest of the evening.

So our days went by and nothing affected their uniformity, except that in summer, instead of sitting round the fireplace, we sat on benches that stood by the door. Three whole years passed in such sweet tranquillity, and now they seem to me like so many weeks.

When I reached my seventeenth birthday, my father thought to have me join the Walloon Guards, and he wrote on the matter to those of his former comrades on whom he most relied. These worthy and respectable soldiers pooled together on my behalf all the influence they had, and obtained a captain's commission. When my father received news of it, he felt such a violent rush of emotion that we feared for his life. But he quickly recovered, with no other thought but for the preparations for

my departure. He wanted me to go by sea, so as to enter Spain via Cadiz, and to present myself first of all to Don Henri de Sa, commander of the province, who had contributed the most to my advancement.

When the post chaise stood already fully harnessed in the castle courtyard, my father led me into his room, and having closed the door, said to me:

"My dear Alphonse, I am going to tell you a secret that was told to me by my father, and which you will tell to no one but your son, when you consider him worthy of it."

Since I had no doubt it was a matter of some hidden treasure, I replied that I had never regarded gold as anything but a means of coming to the aid of the needy.

But my father replied: "No, my dear Alphonse, this is not a matter of gold or of money. I want to teach you a secret lunge with which, by parrying with the counter and marking the flanconade, you are sure of disarming your enemy."

Then he took some foils, showed me the lunge in question, gave me his blessing and led me to my carriage. I kissed my mother's hand again, and set off.

I travelled by post as far as Flushing, where I found a vessel that brought me to Cadiz. Don Henri de Sa welcomed me as though I were his own son. He provided me with a horse and recommended two servants to me, one of whom was called Lopez and the other Mosquito. From Cadiz, I went to Seville, and from Seville to Cordoba, then I came to Andujar, where I took the road to the Sierra Morena. I had the misfortune to be separated from my servants near the Los Alcornoques drinking-trough. However, I arrived the same day at Venta Quemada and yesterday reached your hermitage.

"My dear child," said the hermit, "your story has greatly interested me, and I am very obliged to you for having been good enough to tell it to me. I now see clearly, from

the manner in which you have been brought up, that fear is a sentiment that must be completely unknown to you. But since you have spent the night at Venta Quemada, I am much afraid that you may be exposed to the molestations of the two hanged men, and that you may suffer the sad fate of the demonaic."

"Father," I answered the anchorite, "I have given a great deal of thought during the night to Signor Pacheco's story. Although he is possessed by the devil, he is none the less a gentleman and, as such, I believe him to be incapable of failing in his duty to the truth. But Inigo Velez, our castle chaplain, told me that although there were demoniacs in the early centuries of the Church's history, now there were no longer any, and his word seems to me all the more worthy of respect since my father instructed me to believe Inigo in all matters relating to our religion."

"But," said the hermit, "have you not seen the dreadful appearance of the man, and how the demons have made him blind in one eye?"

I replied: "Father, Signor Pacheco may have lost his eye in some other way. Besides, on all these matters I put my faith in the judgement of those who know more about them than I. It is enough for me that I am not afraid of ghosts or vampires. However, if you want to give me some holy relic to protect me from their importunings, I promise to wear it with faith and reverence."

The hermit appeared to smile a little at this naivety, then he said to me: "I see, my dear child, that you still have faith, but I fear that you will not persist in it. These Gomelez, from whom you are descended through the female line, are all latter-day Christians. Some are even Muslim at heart, so it is said. If they offered you a huge fortune to change your religion, would you accept?"

"Certainly not," I replied. "I think that to renounce one's religion or to desert one's flag are two equally dishonourable things."

At this, the hermit again seemed to smile, then he said: "I am sorry to see that your virtues rest on a far too extravagant code of honour, and I warn you that you will no longer find Madrid as swashbuckling as it was in your father's day. Moreover, virtues have other foundations that are more sound. But I do not want to delay you any longer, for you have a day's hard riding ahead of you before you reach Venta del Peñon, or the Rock Tavern. The innkeeper has stayed on there, despite the robbers, because he relies on the protection of a band of gypsies who are camped nearby. The day after tomorrow, you will reach Venta de Cardeñas – by then you will already be out of the Sierra Morena. I have put some provisions in the pockets of your saddle."

Having said these things, the hermit embraced me warmly, but he did not give me any relic to protect me from the fiends. I did not want to mention it to him again, and I mounted my horse.

As I journeyed, I began thinking about the maxims I had just heard, unable to imagine how there could be any more solid foundation for virtue than the code of honour, which seemed to me in itself alone to embrace all virtues.

I was still preoccupied with these thoughts when a horseman, suddenly riding out from behind a rock, cut across my path and said: "Is your name Alphonse van Worden?"

I replied that it was.

"If that is so," said the horseman, "I arrest you in the name of the King and the Most Holy Inquisition. Surrender your sword."

I obeyed without argument. Then the horseman whistled and I saw armed men bear down upon me from all sides. They tied my hands behind my back, and we took a byroad into the mountains that led us an hour later to a heavily fortified castle. The drawbridge was lowered and we went in. While we were still under the keep, a side-door was opened and I was thrown into a cell, without

anyone even taking the trouble to untie the ropes that bound me.

The cell was totally dark, and not having a free hand to stretch out in front of me, I would have had difficulty in advancing without banging my nose against the walls. That is why I sat down right where I was, and as anyone might readily imagine, I began to reflect on what could have given rise to my imprisonment. My first and only thought was that the Inquisition had seized my lovely cousins, and the negresses had reported everything that had happened at Venta Quemada. Assuming that I was to be interrogated about the Africans beauties, the only choice I had was either to betray them and break my word of honour, or deny that I knew them, which would have involved me in a series of shameful lies. After having deliberated on what course to adopt, I decided upon the most absolute silence, and I firmly resolved not to respond at all to any questioning.

Once this doubt was removed from my mind, I began to muse upon the events of the two preceding days. I did not doubt that my cousins were women of flesh and blood. I was convinced of it by some inexplicable feeling stronger than everything that had been said to me about the power of demons. As for the trick that had been played upon me, of placing me under the gibbet, I was extremely indignant about it.

Meanwhile, the hours went by. I was beginning to feel hungry, and since I had heard that cells were sometimes provided with bread and a jug of water, I began to explore with my legs and feet in the hope of finding something of the kind. Indeed I soon felt a foreign body that turned out to be half a loaf of bread. The difficulty was bringing it to my mouth. I lay down beside the bread and tried to catch hold of it with my teeth, but it eluded me and slipped away for want of some resistance. I pushed it so far, I forced it up against the wall. Then I was able to eat, because the loaf was cut down the middle. Had it been whole, I should not have been able to bite into it. I also

found a jug, but it was impossible to drink from it. Hardly had I wet my throat when all the water poured away. I carried my explorations further: I found some straw in a corner and lay down on it. My hands were skilfully tied – in other words, very tightly – but without hurting me. So it was that I had no difficulty in falling asleep.

THE FOURTH DAY

It seemed to me that I had slept for several hours when they came to wake me. I saw a monk of St Dominic enter my cell, followed by several men of very ugly demeanour. A few held torches; others, instruments that were altogether unknown to me and which I decided must be used for torture. I remembered what I had determined to do and my resolution grew stronger. I thought of my father. He had never undergone torture, but had he not suffered a thousand painful operations at the hands of surgeons? I knew that he had endured these without a single complaint. I resolved to follow his example, not to utter a word and, if possible, not to let a sigh escape me.

The inquisitor had a chair brought for him, sat next to me, assumed a mild and ingratiating air, and spoke to me more or less in these words: "My dear child, give thanks to heaven that led you to this cell. But tell me, why are you here? What sin have you committed? Make your confession, shed your tears on my breast... You do not answer me? Alas, my child, in this you are at fault... We do not interrogate, that is not our method. We leave it to he who is guilty to accuse himself. This confession, although somewhat forced, is not without merit, especially when the guilty man denounces his accomplices. You do not answer? So much the worse for you... Well, we shall have to set you on the right path. Are you acquainted with two princesses from Tunis? Or rather, two infamous witches, execrable vampires and devils incarnate? You say nothing. Have the two infantas of Lucifer's court sent in!"

At this point my two cousins, who, like me, had their hands tied behind their backs, were brought in.

Then the inquisitor continued in these terms: "Now then, my dear son, do you recognize them? Still you say nothing! My dear son, do not be alarmed at what I about to tell you: we are going to hurt you a little. You see these

two planks: your legs will be placed between them, they will be secured tightly with a rope. Then these wedges that you see here will be driven between your legs, they will be hammered in. First your feet will swell up. Then blood will spurt from your big toes, and the nails on your other toes will all drop off. Then the soles of your feet will split open and a fatty substance mixed with crushed flesh will ooze out. This will be extremely painful. You have nothing to say: well, all that is just the usual torture. However, you will lose consciousness. These are phials filled with various spirits with which you will be revived... When you have regained your senses, those wedges will be removed and replaced with these, which are much bigger. At the first blow, your knees and heels will shatter. At the second, your legs will split length-ways. The marrow will spill out and run on to this straw, mixed with your blood... You will not speak? Very well, apply the thumb-screws!"

The torturers took my legs and tied them between the planks.

"You will not speak? Position the wedges! You will not speak? Raise the hammers!"

At that moment there was a sound of gunfire. Emina cried out: "O Muhammad! We are saved. Zoto has come to our rescue."

Zoto came in with his gang of men, threw out the torturers, and tied the inquisitor to a ring in the wall of the cell. Then he unbound us, the two Moorish women and myself. The first thing they did when their arms were freed was to throw themselves in mine. Someone had to disengage us. Zoto told me to mount a horse and to ride on ahead, assuring me that he would soon follow with the two ladies.

The advance party with which I set off consisted of four horsemen. At daybreak we reached a very lonely spot, where we found a post house. Then we kept to the high peaks and the crests of snow-capped mountains.

At about four o'clock we reached some rock cavities, where we were to spend the night. But I heartily congratulated myself on having come there while it was still light, for the view was splendid and must have seemed especially so to me, who had seen nothing but the Ardennes and Zealand. At my feet lay the lovely Vega de Granada, which the people of Granada, in the face of truth, call *la Nuestra Vegilla*. I could see it all, with its six towns, its forty villages – the most magnificent view lying before me. Enchanted to find that my eyes could behold so many lovely things at once, I surrendered myself to gazing upon them. I felt I was becoming a lover of nature. I forgot my cousins; yet soon they arrived in litters borne by horses.

They sat down on flagstones in the cavern and when they were a little rested, I said to them: "Ladies, I have no complaint about the night I spent at Venta Quemada, but I confess it ended in a way I found immensely disagreeable."

Emina replied: "Alphonse, hold us responsible only for the good part of your dreams. But what have you to complain about? Did you not have the opportunity to show superhuman courage?"

"What!" I said. "Are you suggesting that someone has questioned my courage? If I knew where to find that person, I would fight a duel with him on whatever conditions he might choose."

Emina replied: "I don't know what you are talking about! There are some things I cannot tell you. There are others I do not know myself. I act only on the orders of the head of our family, Sheikh Massoud's successor, who knows the secret of Cassar Gomelez in its entirety. All I can say is that you are our very close relative. The *oidor* of Granada, your mother's father, had a son who was found worthy of being initiated. He embraced the Muslim religion and married the four daughters of the then reigning Dey of Tunis. Only the youngest of the daughters had any children, and she is our mother. Shortly after the birth of Zibedde, my father and his three other wives died in

77

an outbreak of disease that at that time ravaged the whole Barbary coast... But let us leave aside all these things that perhaps one day you will come to know. Let us talk of you, of the gratitude we owe you, or rather our admiration for your virtues. With what indifference you viewed the preparations for torture! What religious respect for your word of honour! Yes, Alphonse, you outshine all the heroes of our race and we now belong to you."

Zibedde, who willingly let her sister talk when the conversation was serious, reclaimed that privilege when it took a sentimental turn. In short, I was flattered, gratified, pleased with myself and with others. Then the negresses arrived; we were given supper and Zoto himself served us, with the most profound marks of respect. Then the negresses made up a reasonably comfortable bed for my cousins in a kind of cave. I went to sleep in another, and we all enjoyed the rest we needed.

THE FIFTH DAY

The next day our party made an early start. We came down from the mountains and wound our way through sunken valleys, or rather through chasms that seemed to reach down to the entrails of the earth. These cut through the chain of mountains in so many different directions it was impossible to get one's bearings, or to know which way one was heading.

We continued like this for six hours, and came to the ruins of a deserted and desolate town. There, Zoto told us to dismount, and leading me to a well, he said:

"Signor Alphonse, will you be so kind as to look into this well and tell me what you think of it."

I told him that I could see water in it and that this well seemed to me in no way different from any other.

"Well," said Zoto, "you are mistaken, for it is the entrance to my palace."

Having said this, he stuck his head in the well and gave a shout. A moment later, a heavy stone, supported on chains, was lowered to a few feet above the water, forming a kind of drawbridge. Then two armed man appeared, who were soon at the top of the well. When they were out, Zoto said to me:

"Signor Alphonse, I have the honour of presenting to you my two brothers, Cicio and Momo. Perhaps you saw their bodies strung up on a certain gibbet, but they are none the less in good health, and will always be your devoted servants, being, as I am, in the service and in the pay of the Grand Sheikh of the Gomelez."

I replied that I was delighted to meet the brothers of a man who appeared to have rendered me such a great service.

We had to reconcile ourselves to a descent into the well. A rope ladder was brought, which the two sisters used with greater ease than I had expected. I went down after them. When we reached the stone drawbridge, we found

a small side-door, through which one could pass only by stooping very low. But immediately afterwards we found ourselves on a splendid staircase carved out of the rock, lit by lamps. We went down more than two hundred steps. Finally we entered a subterranean residence, consisting of numerous rooms and chambers. The walls of the living quarters were lined with cork, which protected them against dampness. I have since seen at Cintra, near Lisbon, a convent carved out of the rock, whose cell-walls were also lined in this way, and which is known, because of this, as the Cork Convent.

In addition, some well-placed warm fires gave Zoto's underground dwelling a very pleasant temperature. The horses that served his troops were scattered in the vicinity. Yet, in case of need, they could also be brought into the earth's bosom, through a passage that opened onto a neighbouring valley, and there was a specially made contraption to hoist them up, but this was rarely used.

"All these wonders", Emina told me, "are the work of the Gomelez. They dug out this rock during the time when they were masters of the area – that is to say, they finished digging it out, for the idolaters who were living in the Alpujarras when they arrived had already done much of the work. Scholars claim that in this very place were the mines that produced the gold native to Baetica, and ancient prophesies predict that one day the whole country is to return to the power of the Gomelez. What do you say to that, Alphonse? Would it not be a fine inheritance!"

Emina's words seemed to me very out of place. I told her so. Then changing the subject, I asked her what her plans for the future were.

Emina replied that after what had happened, they could not any longer remain in Spain, but that they wanted to rest a little until preparations for their sailing had been made.

We were given a very generous meal, mostly of venison, and a lot of dried preserves. The three brothers

served us with the utmost willingness. I mentioned to my cousins that one could not hope to find more honest hanged men. Emina agreed, and said to Zoto:

"You and your brothers must have had some very strange adventures, it would give us great pleasure if you would tell us about them."

After some persuasion Zoto sat down in our midst and began with these words:

The story of Zoto

I was born in the town of Benevento, capital of the duchy of that name. My father, who, like me, was called Zoto, was a gunsmith skilled in his craft. But as there were two others in the town of even greater repute, his trade barely sufficed to keep him, with his wife and three children – in other words, my brothers and myself.

Three years after my father had married, a younger sister of my mother married an oil merchant, called Lunardo, who gave her as a wedding present a pair of gold earrings with a chain of the same metal to wear round her neck. On the way home after the wedding, my mother seemed sunk in a deep gloom. Her husband wanted to know the reason why. For a long time she refused to tell him. Finally she confessed that she had a mortal longing for some earrings and a necklace like her sister's. My father said nothing. He had a shotgun of the finest crafts-manship, with pistols to match, as well as a hunting-knife. The gun fired four shots without being reloaded.

My father had worked on it for four years. He judged it to be worth three hundred ounces of Naples gold. He went to a collector, sold all the mountings for eighty ounces. Then he went to buy the jewellery his wife had hankered after, and brought it to her. My mother went that very day to show them to Lunardo's wife, and her earrings were even thought to be a little more costly than her sister's, which gave her the utmost pleasure.

But a week later Lunardo's wife came to my mother's house to return her visit. Her hair was braided and coiled, and held in place with a gold pin, the head of which was a filigree rose embellished with a small ruby. This golden rose drove a cruel thorn into my mother's heart. She fell back into her state of melancholy and only recovered from it when my father had promised her a pin like that of her sister. However, since my father had neither the money nor the means to obtain one, and since a pin of that kind cost forty-five ounces, he soon became as melancholy as my mother had been a few days before.

Meanwhile, my father received the visit of a local bravo named Grillo Monaldi, who came to him to have his pistols cleaned. Noticing my father's gloominess, Monaldi asked him the cause of it, and my father did not hide it from him. After a moment's reflection Monaldi spoke to him in these words:

"Signor Zoto, I am more indebted to you than you know. The other day, it so happened that my dagger was found in the body of a man murdered on the road to Naples. Officers of the law had this dagger taken to all armourers, and you generously attested to having no knowledge of it. Yet it was a weapon you had made and sold to me. If you had told the truth, you could have placed me in a difficult position. So here are the forty-five ounces you need, and furthermore my purse will always be open to you."

My father gratefully accepted, went to buy a gold pin embellished with a ruby and took it to my mother, who

did not fail to show it off that very day to her arrogant sister.

Once back at home, my mother had no doubt that the next time she saw Signora Lunardo, she would be wearing some new piece of jewellery. But her sister had something very different in mind. She wanted to go to church with a hired liveried footman in attendance, and she had put the idea to her husband. Lunardo, who was very miserly, had gladly consented to the purchase of some piece of gold that, basically, seemed as safe on his wife's head as in his own purse. But it was quite another matter being asked to give a rascal an ounce of gold, just to stand behind his wife's pew for half an hour. However, Signora Lunardo nagged him to such a degree and so often that he finally made up his mind to attend upon her himself, dressed in livery. Signora Lunardo considered her husband as good anyone else for this job, and the very next Sunday she insisted on appearing at the parish church attended upon by this new species of footman. The neighbours laughed a little at this masquerade, but my aunt simply attributed their jests to their consuming envy.

When she came near the church, the beggars hooted and jeered, and shouted after her in their argot: "*Mira Lunardu che fa lu criadu de sua mugiera!*"

However, since tramps will not carry their effrontery beyond a certain point, Signora Lunardo entered the church unimpeded, where she was accorded all kinds of honours. She was offered holy water, and shown to a pew, whilst my mother remained standing, lost in the crowd of women of the lowest class of the populace.

On her return home, my mother immediately took a blue suit of my father's, and began to trim the sleeves with a piece of yellow bandoleer that had belonged to the cartridge-pouch of a Spanish brigand. Taken aback, my father asked her what she was doing. My mother told him the whole story about her sister, and how her husband had indulged her by attending upon her dressed in livery.

My father assured her that he would never be so indulgent. But the following Sunday he gave an ounce of gold to a hired footman, who attended upon my mother at church, where she cut an even better figure than Signora Lunardo the previous Sunday.

That same day, straight after Mass, Monaldi came to my father's house and said the following:

"My dear Zoto, I have been told about the competition between your wife and her sister to outdo each other in extravagance. If you don't do something about it, you will be wretched for the rest of your life. So you have only two courses open to you: one is to beat your wife, the other is to take up a profession that will enable you to satisfy her taste for spending. If you adopt the first course, I will give you a hazel stick that I used on my late wife while she was alive. If you take it by one end and apply the other to your wife's shoulders, I assure you, you will easily cure her of all her caprices. If, on the other hand, you decide to satisfy your wife's every whim, I will offer you the friendship of the bravest men in all Italy. They are given to meeting at Benevento, because it is a border town. I think you understand me, so think it over."

Having said this, Monaldi left his hazel stick on my father's workbench and departed.

Meanwhile, my mother had gone, after Mass, to show off her hired footman on the Corso, and to call on some of her friends. She finally came home, all triumphant; but my father gave her quite a different welcome from the one she was expecting. With his left hand, he seized her left arm, and taking the hazel stick in his right hand, he began to put into effect Monaldi's advice. His wife fainted. My father cursed the stick, asked forgiveness, was pardoned, and peace was restored.

A few days later my father sought out Monaldi to tell him the hazelwood had not worked, and that he commended himself to the brave men of whom he had spoken.

Monaldi replied: "Signor Zoto, it is rather surprising that, whilst unable to find it in your heart to inflict the slightest punishment on your wife, you should have it in you to waylay people on the edge of a wood. Yet all things are possible, and the human heart harbours many other contradictions. I am quite willing to introduce you to my friends, but you must have carried out some notable feat beforehand. Every evening, when you have finished your work, take a long sword, put a dagger in your belt, and stroll by the Madonna Gate with something of a swagger. Perhaps someone will come and hire you. Farewell, may heaven bless your ventures!"

My father did as Monaldi had advised him, and soon he noticed that various fellows of his like, and the police, greeted him knowingly.

After two weeks of this my father was accosted one evening by a well-dressed man who said to him: "Signor Zoto, here is one hundred ounces, which I am giving you. In half an hour you will see two young men pass by who will be wearing white feathers in their hats. You will approach them as though you wish to speak to them in confidence, and you will say in an undertone: 'Which of you is the Marquis Feltri?' One of them will say: 'I am.' You will stab him in the heart with your dagger. The other young man, who is a coward, will run away. Then you will finish off Feltri. When the business is done, do not go and take refuge in a church. Return calmly to your house and I shall follow closely on your heels."

My father meticulously carried out the instructions he had been given, and when he was back home, he saw the stranger arrive whose grudge he had settled, and who said to him:

"Signor Zoto, I very much appreciate what you have done for me. Here is another purse containing one hundred ounces, which I beg you to accept, and here is yet another of the same value, which you will give to the first officer of the law who comes to your house."

Having said this, the stranger departed.

Soon afterwards the chief of police turned up at my father's house. My father at once gave him the one hundred ounces intended for the forces of law and order, and the chief of police invited my father to join him and his friends, at home, for supper. They went to a house built onto the back of the public prison, and they found there, as guests, the *barigel* and the prisoners' confessor. My father was a little nervous, as is usual after a first murder.

Noticing his agitation, the clergyman said to him: "Signor Zoto, no gloominess. Masses at the cathedral are twelve *tari* each. It is said that the Marquis Feltri has been murdered. Have twenty Masses said for the repose of his soul, and you will be given general absolution into the bargain."

After that, there was no further mention of what had happened, and the supper was rather jolly.

The next day Monaldi came to my father's house and congratulated him on the manner in which he had proved himself. My father tried to give him the forty-five ounces he had received for it, but Monaldi said to him:

"Zoto, you offend my susceptibilities. If you mention that money again to me, I shall take it that you blame me for not having made enough. My purse is at your service and my friendship is yours. I will hide from you no longer the fact that I myself am the leader of the band I told you about. It is made up of men of honour and of true honesty. If you want to join us, say that you are going to Brescia to buy some gun barrels there, and come and meet us at Capua. Take lodgings at the Croce d'Oro, and don't worry about the rest."

My father set off three days later and fought a campaign as honourable as it was lucrative.

Although the climate of Benevento was very mild, my father, who was not yet experienced in the job, did not want to work in the winter. He spent those winter months in the bosom of his family, and his wife had a footman on

Sundays, gold fasteners on her black bodice, and a gold ring on which to hang her keys.

As spring drew near, it happened that my father was called out into the street by a servant unknown to him, who asked that he should follow him to the gates of the town. There he found an elderly noble and four men on horseback.

The nobleman said to him: "Signor Zoto, here is a purse containing fifty sequins. Would you kindly follow me to a neighbouring castle, and allow yourself to be blindfolded?"

My father agreed to everything, and after a fairly long stretch and several twists and turns, they reached the old nobleman's castle. He was taken inside and his blindfold removed. Then he saw a masked woman, tied in a chair and gagged.

The old man said to him: "Signor Zoto, here is another one hundred sequins. Please be good enough to stab my wife."

But my father replied: "Sir, you have misjudged me. I lie in wait for people at the corner of the street, or I attack them in a wood, as befits a man of honour, but I do not undertake the duties of an executioner."

Whereupon my father threw the two purses at the feet of the vindictive husband. The latter did not insist. He had my father blindfolded once more, and ordered his men to take him to the gates of the town. This noble and generous deed brought much credit to my father; but he subsequently performed another that was even more widely acclaimed.

There were in Benevento two men of quality, one of whom was called the Comte Montalto, and the other the Marquis Serra. The Comte Montalto summoned my father and promised him five hundred sequins to murder Serra. My father agreed to do so, but he asked for time, because he knew that the Marquis was very much on his guard.

Two days later the Marquis Serra summoned my father to an out-of-the-way place and said to him: "Zoto, here is a purse of five hundred sequins. It is yours. Give me your word of honour that you will stab Montalto in the heart."

My father took the purse and replied: "My lord, I give you my word of honour that I will kill Montalto. But I must confess that I have also given him my word of honour to kill you."

The Marquis said with a laugh: "I sincerely hope you won't."

My father replied very seriously: "Forgive me, my lord, I promised to do so, and I will."

The Marquis leapt back and drew his sword. But my father drew a pistol from his belt and shot him dead. Then he went to call on Montalto and told him that his enemy was no more. The Comte embraced him and gave him the five hundred sequins. Then my father confessed, with some degree of embarrassment, that before dying, the Marquis had given him five hundred sequins to murder him.

The Comte said he was delighted to have forestalled his enemy.

"My lord," said my father, "it will do you no good, because I gave my word."

Whereupon he stabbed him. The Comte uttered a cry as he fell, which attracted the servants. My father disposed of them with his dagger, and headed for the mountains, where he joined Monaldi's band. All the cut-throats that belonged to it vied with one another in their praise for so scrupulously keeping his word. I assure you this deed is still, as it were, on everyone's lips, and that it will talked of in Benevento for a long time to come.

When my father went to join Monaldi's band, I was probably seven years old, and I remember being taken to prison – my mother, my two brothers and myself. But it was just for form's sake; since my father had not forgotten

the lawmen's share, they were easily persuaded that we had nothing to do with him.

The chief of police showed particular concern for us during our detention, and he even cut short the length of time we were detained. On leaving prison, my mother was very warmly greeted by the neighbours and the whole district, for in the south of Italy bandits are heroes of the people, just as smugglers are in Spain. We had our share of the universal esteem, and I in particular was considered the prince of little rascals in our street.

About that time, Monaldi was killed in action, and my father, who took command of the band, wanted to make his debut with some spectacular feat. He went and set up ambush on the road to Salerno, to await a delivery of money sent by the Viceroy of Sicily. The venture succeeded, but my father was wounded in the back by a musket-shot, which meant he was unable to serve any longer. The moment when he took leave of the band was extraordinarily moving. It is even said that several of the bandits wept, which I would find hard to believe had I myself not wept once in my life, and that was after having stabbed my mistress, which I shall tell you about in due course.

It was not long before the men disbanded. Some of our cut-throats went to get themselves hanged in Tuscany; others went to join Testalunga, who was beginning to acquire something of a reputation in Sicily. My father himself crossed the strait and went to Messina, where he sought asylum with the Del Monte Augustinians. He placed his small stash of savings in the hands of these holy fathers, did public penance and took up residence under their church portal, where he led a very pleasant life, with the freedom to walk in the gardens and courtyards of the monastery. The monks gave him soup, and he would send to a nearby eating-house for a couple of cooked dishes. The lay brother of the order even dressed his wounds into the bargain.

I suppose that at that time my father was sending us large sums of money, for abundance reigned in our house. My mother took part in the carnival revels, and during Lent she made a crib, or *presepe*, using little dolls, sugar castles and other such childish devices, which are very popular throughout the kingdom of Naples and constitute a luxury item for well-off citizens. My Aunt Lunardo also had a *presepe*, but it was far inferior to ours.

In so far as I can remember my mother, I think she was very good-hearted, and we often saw her weep over the dangers to which her husband exposed himself; but a few triumphs over her sister or her neighbours very quickly dried her tears. The satisfaction her lovely crib gave her was the last pleasure of this kind she was able to enjoy. I do not know how she contracted pleurisy, from which she died a few days later.

After her death we would not have known what was to become of us if the *barigel* had not taken us into his house. We spent several days there, after which we were handed over to a muleteer, who took us all the way across Calabria, arriving on the fourteenth day in Messina. My father was already informed of the death of his wife. He welcomed us very affectionately, had a mat laid down for us beside his own, and introduced us to the monks, who made us choirboys. We served at Mass, we snuffed out the candles, we lit the lamps, and that aside, we were as arrant little rascals as we had been at Benevento. When we had eaten the monks' soup, my father would give us each a *tari*, with which we would buy chestnuts and cracknel, then we would go down to the port to play and not come back before dark. In short, we were happy little scamps... until an incident occurred that even today I cannot recall without a surge of anger, which was to determine the course of my whole life.

One particular Sunday, as vespers were about to begin, I returned to the church portal, carrying chestnuts that I had bought for my brothers and myself, and I was sharing them out when I saw a splendid carriage arrive, harnessed

with six white horses and preceded by two horses of the same colour that ran free – a form of ostentation I have seen only in Sicily. The carriage opened and I saw emerge, first, a gentleman *bracciere* who gave his arm to a beautiful lady, then a priest, and finally a little boy of my own age, with a lovely face and magnficently dressed in the Hungarian style, as children were then quite commonly dressed. His little fur-lined winter coat was of blue velvet, embroidered in gold and trimmed with sable; it came half-way down his legs and even covered the top of his boots, which were of yellow morocco-leather. Also sable-trimmed, his bonnet too was of blue velvet and topped with a tassel of pearls that fell down on one shoulder. His belt was made of gold tassels and sashes, and his little sabre was set with precious stones. Finally, he held in his hand a prayerbook bound in gold.

I was so filled with wonder to see such fine clothes on a boy of my age that, without really knowing what I was doing, I went up to him and offered him two chestnuts that I was holding in my hand; but instead of responding to the small gesture of friendship I was making, the unworthy little wretch bashed me on the nose with his prayerbook, and did so with all the strength he could muster. I was nearly blinded in my left eye, and a lock on the book caught on one my nostrils and tore it, so that I was instantly covered in blood. Then, I think, I also heard the little lordling scream dreadfully, but I had virtually lost consciousness. When I regained it, I found myself by the garden fountain, surrounded by my father and brothers, who were washing my face and trying to stop the bleeding.

However, I was still covered with blood when we saw the little lordling return, followed by his priest, the gentleman *bracciere* and two footmen, one of whom was carrying a bundle of birch rods. The gentleman explained briefly that the Princess de Rocca Fiorita insisted I should be thrashed till I bled, as punishment for the fright I had

given her Principino, and the footmen at once started to carry out the sentence.

My father, who was afraid of losing his asylum, at first dared not say anything, but seeing me mercilessly torn to pieces, he could not contain himself, and addressing the gentleman with all the accents of suppressed rage, he said to him: "Put a stop to this, or remember, I have killed men worth ten such as you."

Deciding that these words contained a great deal of sense, the gentleman gave the order that my torture should cease. But while I still lay on my stomach, the Principino came up to me and kicked me in the face, saying: "*Managia la tua facia de banditu.*"

This final insult made me angrier than ever. I can say that from that moment I ceased to be a child, or at least I never again savoured the sweet joys of childhood. And for a long time afterwards I could not look with composure upon a richly dressed man.

Vengeance must be our country's original sin, for although I was only eight years old, my only thought, night and day, was of punishing the Principino. I would start awake, dreaming that I held him by the hair and was thrashing him soundly. And by day, I would think of how to hurt him from a distance, for I was sure I would not be allowed near him. Besides, I wanted to run away once I had achieved my end. Finally I decided to throw a stone in his face, a form of activity at which I was already quite skilled. However, to improve my performance, I chose a target against which I spent nearly all day practising.

On one occasion my father asked me what I was doing. I told him it was my intention to smash the Principino's face, and then to run away and become a bandit. My father appeared not to believe what I was saying, but he smiled at me in a way that hardened my resolve to carry out my plan.

At last came the Sunday that was to be my day of vengeance. The carriage appeared, the passengers climbed out. I was very agitated, but I pulled myself

together. My young enemy identified me in the crowd and stuck out his tongue at me. I was holding my stone. I threw it and he fell back. I immediately began to run and did not stop until I reached the other end of town. There I encountered a chimney-boy of my acquaintance, who asked me where I was going. I told him my story and he at once led me to his master. Being short of boys and not knowing where to find any for such arduous work, the man greeted me with pleasure. He told me that no one would recognize me once my face was stained with soot, and that climbing chimneys was a skill that very often proved useful. In this he did not deceive me. I have often owed my life to the skill I acquired then.

I found the dust from the chimneys and the smell of the soot very unpleasant at first, but I got used to them, for I was of an age when one adapts to everything. I had been practising my trade for about six months when the adventure I am about to relate befell me.

I was on a roof, listening attentively to hear which flue my master's voice would emerge from. I thought I could hear him shouting up the chimney nearest to me. Down I went, but I found that under the roof the flue divided in two. At that point I should have called out, but I did not, and I foolishly opted for one of the openings. I slid down and found myself in a handsome drawing room, but the first thing I noticed in it was my Principino, wearing nothing but his shirt, playing with a shuttlecock.

Although the little fool had doubtless seen other chimney-boys, he took it into his head to mistake me for the devil. He fell to his knees and begged me not to carry him off, promising to be good. His pleas might well have moved me, but I was holding in my hand my little chimney-sweep's broom, and the temptation to make use of it had grown too strong. Besides, I had certainly been avenged for the blow the Principino had given me with his prayerbook, and in part for the beating with birch rods, but the kick in the face he had given me, with the words "*Managia la tua facia de banditu*", still rankled. And

after all, a Neapolitan likes to take a little more vengeance rather than a little less.

So I removed a fistful of switches from my broom. Then I tore open the Principino's shirt and when his back was bared I tore that too, or at least I gave it some rather harsh treatment, but what was most odd was that fear prevented him from crying out.

When I thought I had done enough, I wiped my face and said to him: "*Ciucio maledetto, io no zuno lu diavolu, io zuno lu piciolu banditu delli Augustini.*"

Then the Principino recovered the use of his voice and began to cry for help, but I did not wait until someone came; I climbed back up the way I had come.

When I was on the roof, I heard my master's voice again, calling for me, but I did not think it wise to reply. I began to run from roof to roof, until I came to the roof of a stable before which stood a haycart. I threw myself from the roof down on to the haycart, and from the haycart to the ground. Then I raced to the Augustinians' portal, where I told my father everything that had just happened to me.

My father listened with great interest, then said to me: "Zoto, Zoto! *Già vegio che tu sarai banditu.*"

Then turning to a man beside him, he said: "*Padron Lettereo, prendete lo chiutosto vui.*"

Now then, Padron Lettereo was the captain of a vessel equipped supposedly for coral-fishing, but actually used for smuggling and even piracy, whenever the opportunity presented itself. Which did not happen very often, because it carried no cannon and had to take ships by surprise in deserted coves.

All this was known in Messina, but Lettereo smuggled for the town's principal merchants. The customs clerks got their share, and besides, the captain was thought to be very free with his knife, which carried some weight with those who might have wished to cause him trouble. Finally, he cut a truly imposing figure. His size and build alone would have sufficed to draw attention, but all the

rest of his outward appearance was so much in keeping that people of a fearful disposition did not lay eyes on him without a rush of fear. His face, already a very dark brown, had been made even darker by a blast of gunpowder, which had left a lot of marks on it, and his brownish-grey skin was heavily wrought with various very unusual designs. It is the practice amongst almost all sailors in the Mediterranean to get themselves tattooed on the arms and on the chest with monograms, outlines of galleys, crosses and other similar devices. But Lettereo had taken this practice further. He had a crucifix etched on one of his cheeks, and a madonna on the other, although only the top of these images was visible, since the bottom half was concealed in a thick beard, which never came into contact with a razor and which scissors alone kept within certain bounds. Add to this, gold rings in his ears, a red bonnet, a belt of the same colour, a sleeveless jerkin, sailor's trousers, bare arms and feet, and pockets full of gold: such was the captain.

It is said that in his youth he had enjoyed amorous adventures with some very high-ranking ladies. Even at that time, he was a favourite with the ladies of his own social status and the terror of their husbands.

Finally, to complete your introduction to Lettereo, I will tell you that he had been the close friend of a man of real merit, who has since earned himself a reputation under the name of Captain Pepo. They had served together with the Maltese corsairs. Then Pepo had entered the service of his king, while Lettereo, who held honour less dear than money, had decided to enrich himself by all manner of means and at the same time had become the irreconcilable enemy of his former comrade.

My father, who had nothing to do in his asylum but dress his wound, having given up hope of its ever completely healing, would readily enter into conversation with heroes of his own stamp. This was the foundation of his friendship with Lettereo, and in commending me to the smuggler, he had grounds for hoping I would not

be refused. He was not mistaken. Lettereo was even appreciative of this mark of trust. He promised my father that my apprenticeship would be less tough than the cabin-boy's usual experience and he assured him that, since I had been a chimney-sweep, it would not take me two days to learn to climb the rigging.

As for me, I was delighted, for my new job seemed to me a nobler one than cleaning chimneys. I embraced my father and my brothers, and cheerily set off with Lettereo to join his ship. When we were aboard, the captain called together his crew, consisting of twenty men, whose faces were pretty much a match for his own.

He introduced me to these gentlemen and addressed them in these words: "*Anime managie, quista criadura e lu filiu de Zotu, se uno de vui a outri li mette la mano sopra io li mangio l'anima.*"

This recommendation had exactly the effect it was supposed to. They even wanted me to eat in the mess, but I saw two cabin-boys of my own age serving the sailors and eating their leftovers, so I did likewise. I was left to it, and even liked for it. But afterwards, when they saw how I climbed the lateen yard, everyone was quick to congratulate me (it being much less dangerous to stand on the yard of sails other than the lateen sail, for they are always in a horizontal position).

We set sail and on the third day reached the Strait of St Bonifacio, which separates Sardinia from Corsica. We found more than sixty boats there, engaged in coral-fishing. We too started to fish, or rather pretended to. But I personally learned a great deal from it, for within four days I was swimming and diving with the most fearless of my companions.

After a week our little flotilla was dispersed by a gregale; this is the name given in the Mediterranean to a north-easterly wind. Every vessel made for safety as best it could. As for us, we came to an anchorage known by the name of St Peter's harbour. This is a deserted beach on the coast of Sardinia. We found there a Venetian

polacca, which seemed to have suffered considerable damage from the storm. Our captain immediately formed designs on this vessel, and dropped anchor very close to it. Then he sent some of his crew down into the hold, so as to appear less heavily manned, which was almost an unnecessary precaution since lateen-rigged vessels are always more heavily manned than others.

Lettero, who kept the Venetian crew under constant observation, saw that it consisted only of the captain, the bosun's mate, six seamen and a cabin-boy. He observed, moreover, that the topsail was torn and saw it taken down for mending, for merchant vessels do not have a change of sails. On the strength of these observations, he placed eight shotguns and as many sabres in the longboat, covered the lot with a tarpaulin, and resolved to wait for the right moment.

When the weather turned fine again, sure enough, the sailors climbed the topmast to unfurl the sail, but since they were not doing it right, the bosun's mate went up too, and was followed by the captain. Then Lettereo had the longboat launched, slipped into it with seven crewmen, and boarded the polacca from the rear. The captain, who was on the yard, shouted down to them: "*A larga ladron, a larga.*"

But Lettereo aimed his gun at him and threatened to kill the first person who tried to come down. The captain, who seemed a determined man, threw himself at the stay-ropes of the mainmast in an attempt to come down. Lettereo shot him in midair. He fell into the sea and was not seen again.

The sailors begged for mercy. Lettereo left four men to keep them at bay, and with the other three he began to search below deck. In the captain's cabin he found a barrel of the kind used to contain olives, but since it was rather heavy and carefully hooped, he decided there was probably something else inside it. He opened it and was pleasantly surprised to find several bags of gold. This was all he wanted, and he sounded the retreat. The raiding party

came back aboard, and we set sail. As we rounded the rear of the Venetian vessel, we again shouted in jest: "*Viva San Marco!*"

Five days later we reached Leghorn. The captain straightaway called on the Consul of Naples with two of his men, and there made his declaration, "according to which his crew had fallen into quarrel with that of a Venetian polacca, and the Venetian captain had unfortunately been pushed by a sailor and had fallen into the sea." Some of the contents of the olive barrel was used to give this story a greater semblance of truth.

Lettereo, who had a marked taste for piracy, would doubtless have attempted other ventures of this kind; but at Leghorn a new commerce was suggested to him, to which he gave his preference. Having observed that the Pope and the King of Naples made large profits from their copper coinage, a Jew named Nathan Levi also wanted to share in this gain. This is why he had similar coins made, in a town in England called Birmingham. When he had a certain quantity, he placed one of his agents in La Flariola, a fishing village situated on the border between the two states, and Lettereo undertook to transport and unload the merchandise there.

The profits were considerable, and for more than a year we did nothing but come and go, always laden with our Roman and Neapolitan coins. We might even have been able to continue our voyages for a long time, but Lettereo, who had a genius for speculation, also suggested to the Jew making coins in gold and silver. The Jew followed his advice and set up in Leghorn itself a small factory of sequins and scudi. Our profits excited the jealousy of the authorities. One day when Lettereo was in Leghorn and about to set sail, someone came to tell him that Captain Pepo had orders from the King of Naples to take his ship, but could not put to sea before the end of the month. This false warning was simply a ruse on the part of Pepo, who had already been at sea for four days. Lettero was taken

in by it. The wind was favourable, he thought he could make another voyage, and set sail.

The next day, at dawn, we found ourselves in the midst of Pepo's flotilla, composed of two galiots and two *scampavies*. We were surrounded, there was no way of escape. Lettereo was staring death in the face. He spread every sail and set his course on the captain's vessel. Pepo was on the bridge, issuing orders for boarding.

Lettero picked up a shotgun, took aim, and hit him in the arm. All this happened in a matter of a few seconds.

Soon after, the four vessels began to converge upon us, and we heard on all sides: "*Mayna ladro, mayna can senza fede.*"

Lettereo close-hauled, so that our side of the ship was skimming the surface of the water. Then addressing the crew, he said to us: "*Anime managie, io in galera non ci vado. Pregate per me la santissima Madonna della Lettera.*"

We all went down on our knees. Lettereo put some cannonballs in his pocket. We thought that he meant to throw himself into the sea. But the cunning pirate did not go about it in that way. There was a big barrel, full of copper, secured on the windward side. Lettereo armed himself with a hatchet and cut the ropes. The barrel immediately rolled to the opposite side, and as we were already heeling hard over, it made us completely capsize. First, the rest of us who were on our knees all fell on to the sails, and when the ship sank, these, because of their elasticity, fortunately threw us some distance the other way.

Pepo fished us all out, with the exception of the captain, one sailor and one cabin-boy. As we were pulled out of the water, we were tied up and thrown into the hold. Four days later we put in to Messina. Pepo informed the authorities that he had some fellows deserving of their attention to hand over. Our disembarcation was not lacking in a certain pomp. It was exactly the time of the Corso, when all the nobility stroll along what is called La

Marina, or the sea front. We walked along solemnly, with policemen before and behind.

The Principino was among the spectators. He recognized me as soon as he laid eyes on me, and cried out: "*Ecco lu piciolu banditu delli Augustini.*"

At the same time he flew at me, grabbed me by the hair, and scratched my face. Since I had my hands tied behind my back, I had difficulty in defending myself.

However, recalling something I had seen done to some English sailors in Leghorn, I freed my head and rammed it into the Principino's stomach. He fell backwards. Then getting to his feet in a fury, he drew a small knife from his pocket and tried to stab me with it. I dodged out of the way and tripped him up, causing him to fall extremely heavily. He even cut himself as he fell, with the knife he was holding. The Princess, who appeared on the scene at this point in the proceedings, again wanted to have me beaten by her servants. But the police would not allow it and took us to prison.

The trial of our ship's company did not last long. The men were sentenced to be strappadoed and then to spend the rest of their days in the galleys. As for the cabin-boy who had survived and myself, we were released, since we were not of age. As soon as we were freed, I went to the Augustinian monastery. But my father was no longer there. The brother porter told me he had died, and that my brothers were cabin-boys on a Spanish vessel. I asked to speak to the Prior. I was taken to see him, and told my story, not forgetting the head-butting and the tripping-up of the Principino.

His Reverence listened to me with great kindness, then said to me: "My child, your father left a considerable sum of money to the monastery when he died. It was wealth dishonestly come by, to which you had no right. It is now in God's hands and must be used to provide for those who serve him. However, we have presumed to draw on these funds to give some écus to the Spanish captain who has taken charge of your brothers. As for you, we can no

longer give you asylum in this monastery, out of respect for the Princess de Rocca Fiorita, our illustrious benefactress. But, my child, you will go to the farm we have at the foot of Mount Etna and there you will quietly spend your childhood years."

Having told me this, the prior called a lay brother and gave him instructions concerning my future.

The next day I departed with the lay brother. We reached the farm, which became my home. From time to time I would be sent into town on errands, for things that could be got more cheaply there. On these little trips I did my best to avoid the Principino. Yet once when I was buying chestnuts in the street, he happened to pass by, recognized me, and had me soundly thrashed by his lackeys. Some time afterwards I gained access to his house, by virtue of a disguise, and no doubt it would have been easy to kill him – every day since, I regret not having done so. But at that time I was not yet familiar with such procedures, and I contented myself with roughing him up. Throughout the early years of my adolescence, not six months, or even four, went by without my having some encounter with that wretched Principino, who often had the advantage of numbers over me. At last I reached the age of fifteen, and though still a child in terms of age and reason, in strength and courage I was nearly a man, which should come as no surprise, considering how the sea air, and then that of the mountains, had fortified my constitution.

So I was fifteen when I first set eyes on the brave and worthy Testalunga, the most honest and virtuous bandit there has ever been in Sicily. Tomorrow, with your permission, I will tell you all about this man, whose memory will live for ever in my heart. For the moment, I must leave you. The administration of my cavern is a painstaking and demanding job to which I must attend.

Zoto left us, and we all made comments on his story that reflected each individual's character. I confessed to being

unable to deny to men as courageous as those he described a kind of regard. Emina said that courage deserves our regard only when used to win respect for virtue. Zibedde said that a young bandit of sixteen was certainly capable of inspiring love.

The two sisters then retired with their negresses to that part of the underground residence that had been set aside for them. They reappeared for supper, then everyone went to bed.

But when everything was quiet in the cavern, I saw Emina come in, bearing a lamp in one hand, like Psyche, and leading her younger sister, who was prettier than Cupid, by the other.

"Alphonse," said Emina, "receive your reward for your heroism. You braved torture rather than betray us. We belong to you, we are your wives. May the holy Prophet perpetuate through us the bloodline of the Abencerrages."

I was not sufficiently casuistic to know to what extent it was permissible for me to listen to such proposals of marriage. I searched for arguments against them. I found none. I stammered out a few words about proprieties, honour, the difference between our creeds. I was silenced. The weakness of my objections ended the discussion in my cousins' favour.

THE SIXTH DAY

The next morning I woke earlier than the day before. I went to see my cousins. Emina was reading the Koran, Zibedde was trying on pearls and shawls. I interrupted these serious occupations with sweet caresses, prompted as much by friendship as by love. Then we dined. After dinner Zoto came to resume his story, which he did in these terms:

The continuation of Zoto's story

I promised to tell you about Testalunga – I am going to be as good as my word. My friend was a peaceful inhabitant of Val Castera, a little town at the foot of Etna. He had a charming wife. The young Prince de Val Castera, while visiting his estates one day, saw this woman, who had come to pay her respects along with the other wives of leading citizens. Far from being duly appreciative of his vassals' tribute offered to him at Beauty's hands, the presumptuous young man had no thought but for the charms of Signora Testalunga. He told her bluntly the effect she had on his senses, and put his hand inside her corset. Her husband was at that moment standing behind his wife. He drew a knife from his pocket and plunged it into the young Prince's heart. I think any man of honour in his place would have done the same.

Having committed this deed, Testalunga retired to a church, where he stayed until nightfall. But believing he would have to take other steps for the future, he decided to join some bandits who had recently taken refuge on the heights of Etna. He went up there and the bandits acknowledged him as their leader.

Etna had at that time spewed out a prodigious quantity of lava; and it was in the midst of these fiery torrents that Testalunga ensconced his band, in haunts whose paths were known only to him. When he had thus made provision for his safety, this brave leader sent word to the Viceroy and asked pardon for himself and his companions. The Government refused, in the fear, I imagine, of compromising its authority.

Then Testalunga began negotiating with the principal farmers of the neighbouring land. He said to them: "Let us steal together: I shall come and ask, you will give me whatever you like and remain none the less blameless before your masters."

It was still stealing, but Testalunga shared everything with his companions and kept nothing for himself beyond what was absolutely essential. On the contrary, if he went through a village, he paid double for everything, so much so that in a short time he became the idol of the people of the Two Sicilies.

I have already told you that several bandits in my father's gang had gone to join Testalunga, who for some years was based to the south of Etna so as to make raids in the Val di Noto and the Val di Mazara. But at the period of which I am speaking – that is to say when I was fifteen years old – the troop returned to the Val Demoni, and one fine day we saw them arrive at the monks' farm.

Whatever you can imagine of sprightliness and sparkle would still not approach that of Testalunga's men. Dressed in brigands' clothes, their hair in silk nets, with pistols and daggers tucked into their belts, a long-bladed sword and a long-barrelled shotgun - such, roughly speaking, was their war apparel. They spent three days

eating our chickens and drinking our wine. On the fourth day someone came to inform them that a detachment of Syracuse dragoons was approaching with the intention of surrounding them. This news made them laugh heartily. They laid an ambush on a sunken road, attacked the detachment and routed them. They were outnumbered ten to one, but each of them carried more than ten fire-arms, and all of the best quality.

After their victory the bandits returned to the farm, and I, who had seen them fighting from afar, was so fired with enthusiasm that I fell at the leader's feet, begging him to let me join his band. Testalunga asked who I was. I replied that I was the son of the bandit Zoto.

At this cherished name, all those who had served under my father gave a cry of joy. Then one of them, taking me in his arms, lifted me on to the table and said: "Friends, Testalunga's lieutenant has been killed in action, and we are at a loss to replace him. Let young Zoto be our lieutenant! Do you not see regiments given to the sons of dukes and princes? Let us do for the son of brave Zoto what is done for them. I guarantee he will prove himself worthy of this honour."

This speech met with loud applause, and I was unani-mously proclaimed Testalunga's second-in-command.

My rank, at first, was just a joke, and each bandit would burst out laughing whenever he called me "*signor tenente*". But they had to change their tune. Not only was I always the first to attack and the last to cover the retreat, but none of them knew as much as me when it came to spying on enemy movements or ensuring the band's rest. Some-times I would climb to the top of rocks to get a better view of the countryside and make the agreed signals, and some-times I would spend whole days in the enemy's midst, only coming down from one tree to climb another. Indeed, it was often the case that I spent the night up the tallest chestnut trees on Etna. And when I could no longer fight off sleep, I would tie myself to the branches with a

belt. All of this presented little difficulty for me, since I had been a cabin-boy and chimney-sweep.

I so distinguished myself in the end that I was given total responsibility for the common safety. Testalunga loved me as his own son, but if I may make so bold, I acquired a reputation that almost exceeded his own, and in Sicily the exploits of young Zoto became the subject of every conversation. So much glory did not leave me unsusceptible to the sweet distractions my age suggested to me. I have already told you that in our part of the world bandits were the heroes of the people, and you can well imagine that the shepherdesses of Etna would not have withheld their love from me. But my heart was destined to succumb to more refined charms, and love was reserving for it a more flattering conquest.

I had been lieutenant for two years and just turned eighteen, when our band was forced to return to the south, because a fresh eruption of the volcano had destroyed our usual retreats. After four days we reached a castle named Rocca Fiorita, the fief and principal abode of my enemy, the Principino.

I scarcely spared a thought any more for the insults I had received from him, but the name of the place revived all my feelings of rancour. This should not surprise you; in our climes, hearts are implacable. If the Principino had been in his castle, I think I would have put the place to fire and sword. I contented myself with doing as much damage as I could, and my companions, who were acquainted with my grounds for doing so, did all they could to help me. The servants in the castle, who had at first tried to offer resistance, could not resist their master's good wine, with which we were most liberal. They fell in with us. In the end we turned Rocca Fiorita into a veritable Land of Plenty.

This life went on for five days. On the sixth our spies warned us that we were about to be attacked by the whole Syracuse regiment, and that the Principino would then arrive with his mother and several ladies from Messina. I

ordered my men to withdraw, but I was curious to stay, and took up position at the top of a leafy oak tree that stood at the far end of the garden. However, I had taken the precaution of making a hole in the garden wall to facilitate my escape.

At last I saw the regiment arrive and make camp in front of the castle entrance, having placed guards all around. Then a succession of litters arrived, inside which were the ladies, and in the last was the Principino himself, lying on a pile of cushions. He climbed out with difficulty, assisted by two equerries, and sent a company of soldiers on ahead. When he was sure that none of us had remained in the castle, he went in with the ladies and a few gentlemen of his retinue.

There was at the foot of my tree a fresh-water spring, a marble table and some benches; it was the most ornamental part of the garden. I assumed it would not be long before the assembled company came down here, and I determined to await them in order to get a closer look. Half an hour later I duly saw a young person of about my own age approaching. Angels are not more beautiful, and the impression she made upon me was so powerful and so immediate that I might have fallen out of my tree had I not been tied to it by my belt – something I sometimes did in order to be able to rest in greater safety.

The young person had downcast eyes and looked extremely melancholy. She sat on a bench, leant over the marble table and shed many tears. Without really knowing what I was doing, I lowered myself out of my tree and stood where I could see her without myself being seen. Then I saw the Principino approach with a bouquet in his hand. It was nearly three years since I had last seen him. He had matured. His face was handsome, although fairly insipid.

When the young person saw him, her physiognomy expressed contempt in a manner much to my liking.

However, the Principino came up to her with a self-satisfied air and said: "My dear betrothed, here is a

bouquet I will give you if you promise me never again to mention that villainous wretch Zoto."

The young lady replied: "My lord, I think you are wrong to place these conditions on your favours, and in any case, even if I were not to mention the charming Zoto, the whole household would speak of him. Did not your nurse herself say she had never seen such a pretty-looking boy, and yet you were there."

Greatly vexed, the Principino replied: "Despicable creature, since you are in love with a bandit, take what you deserve." With that, he slapped her face.

Then the young lady cried out: "Zoto, why are you not here to punish this coward!"

Before she had even finished speaking, I appeared. And I said to the prince: "You ought to recognize me. I am a bandit, and I could kill you. But I repect the young lady who has deigned to call me to her aid, and I am willing to fight as you nobles do."

I was carrying two daggers and four pistols. I divided them equally, set them down ten paces apart, and left the choice to the Principino. But the poor wretch had fallen on to a bench in a faint.

Sylvia then spoke and said to me: "Brave Zoto, I am of noble birth and poor. I was supposed to marry the prince tomorrow, or else be put in a convent. I shall do neither. I want to be yours for life." And she threw herself into my arms.

As you can well imagine, I needed no persuading. However, it was necessary to prevent the prince from impeding our retreat. I took a dagger, and using a stone for a hammer, I nailed his hand to the bench on which he was sitting. He gave a cry and fell back in a faint.

We went out by the hole I had made in the garden wall and regained the mountain heights.

My companions all had mistresses. They were delighted that I should have acquired one, and their ladies swore to obey mine in everything.

I had spent four months with Sylvia when I was forced to leave her in order to take stock of the changes that the recent eruption had brought about in the north. On this trip I discovered in Nature attractions of which I had not previously been aware. I noticed grassy expanses, caves, leafy shade in places where before I would have seen only ambushes and defence positions. Sylvia had at last softened my brigand heart. But it was not long before it recovered all its ferocity.

To come back to my trip north of the Mountain (I use this expression because the Sicilians, when they refer to Etna, always say *il Monte*, in other words, the mountain *par excellence*): I first made for what we call the Philosopher's Tower, but I was unable to reach it. A chasm that had opened on the side of the volcano had spewed forth a flow of lava that forked a little above the tower and joined up again a mile below, forming a completely inaccessible island.

I realized at once the importance of this position, and besides we had inside the tower itself a store of chestnuts that I did not want to lose. By dint of searching, I found an underground tunnel I had used in the past, which led me to the foot of the tower – or rather, right inside it. I decided there and then to install our whole female population on this island. I had some huts built out of foliage. I made one of these as attractive as I could. Then I returned to the South, and brought back the whole colony, which was enchanted with its new refuge.

Now, when I call to mind the time I spent in that happy abode, I see it as though isolated in the midst of the cruel turmoil that has assailed my life. We were separated from the rest of mankind by rivers of fire. There, all obeyed my orders, and all were subject to my beloved Sylvia. Finally, to complete my happiness, my two brothers came to join me. Both had had interesting adventures, and I venture to assure you that if some day you want to hear an account of them it will give you more satisfaction than the story I am telling you.

There are few men who cannot look back on some happy days, but I do not know if there are any who can look back on years of happiness. My own happiness did not last a single year. The fellows in the gang were very honest in their dealings with each other. None of them would have dared to look with desire upon his companion's mistress, still less upon mine. Jealousy was therefore banished from our island, or rather it was only exiled for a while, for this fury finds its way only too easily into those places where love dwells.

A young bandit named Antonino fell in love with Sylvia, and since his passion was very strong, he could not hide it. I noticed it myself, but on seeing how dejected he was, I came to the conclusion that my mistress did not return his love, and I felt easy about it. But I would have liked to cure Antonino, whom I loved for his valour. There was in the gang another bandit called Moro, whom, on the contrary, I hated for his cowardice, and if Testalunga had taken my advice, he would have thrown him out a long time before then.

Moro contrived to win the trust of the young Antonino, and promised to serve his love. He also contrived to get Sylvia to listen to him, and deluded her into thinking that I had a mistress in a neighbouring village. Sylvia was afraid to confront me with the accusation, and her air of constraint I attributed to a change in her feelings towards me. At the same time, on Moro's advice, Antonino redoubled his attentions towards Sylvia, and he took on a look of satisfaction that led me to suppose she was making him happy.

I was not experienced in unravelling plots of this kind. I stabbed Sylvia and Antonino through the heart. Antonino, who did not die at once, revealed to me Moro's treachery. I went after the villain, my bloody dagger in my hand. Terrified at the sight of it, he fell to his knees and confessed that the Prince de Rocca Fiorita had paid him to kill me, as well as Sylvia, and that in fact he had only joined our band to this end. I stabbed him. Then I

went to Messina, and having gained access to the Prince by virtue of a disguise, I dispatched him to the next world to join his henchman and my two other victims. Such was the end of my happiness, and indeed of my glory. My courage turned to total indifference towards life, and as I felt the same indifference for the safety of my companions, I soon lost their trust. In fact, I can assure you that since then I have become the most undistinguished of brigands.

A short time afterwards Testalunga died of pleurisy, and his whole band dispersed. My brothers, who were very familiar with Spain, persuaded me to go there. Placing myself at the head of twelve men, I went into the Bay of Taormina and remained hidden there for three days. On the fourth, we seized a vessel, on which we reached the coast of Andalusia.

Although there are in Spain several chains of mountains that could have offered us suitable hideouts, I gave preference to the Sierra Morena, and I had no cause to regret my decision. I captured two convoys of piastres and pulled off other major coups.

Eventually my successes caused offence at court. The Governor of Cadiz was given orders to take us dead or alive, and sent several regiments after us. Meanwhile, the Grand Sheikh of the Gomelez invited me to enter his service and offered me refuge in this cavern. I accepted without hesitation.

The Court at Granada refused to accept failure. Seeing we could not be found, it had two shepherds from the valley seized and hanged as Zoto's two brothers. I knew those two men, and I know they committed several murders. Yet they are said to be angry at having been hanged in our stead and at night slip free of the gallows in order to cause chaos. I have never been witness to any of this and I don't know what to say about it. However, it is true that I happen to have passed close by the gallows at night on several occasions, and when there was moon-

light I saw clearly that the two hanged men were not there, and in the morning they were back again.

And that, honoured guests, is the story you asked me to tell. I believe that my two brothers, whose lives have not been so wild, would have had more interesting things to relate, but they will not have time to do so, for our ship is ready to sail and I have firm orders it should do so tomorrow.

Zoto withdrew, and the lovely Emina said with sadness in her voice:

"That man was quite right: the time of happiness is all too brief in a person's life. We have had two happy days here such as we may never know again."

Supper was not at all cheerful and I lost no time in wishing my cousins good-night. I hoped to see them again in my bedroom and to be more successful in dispelling their melancholy.

THE SEVENTH DAY

I had fallen asleep and was awakened by a bell that rang twelve times – a bell I had not heard the nights before. Its lugubrious chimes reminded me of the bell at the Venta. I expected to see some apparition. Emina appeared, with Zibedde following her sister. She held her finger to her mouth, as though to urge me to total silence. Emina placed her lamp on the ground. Zibedde removed from around her neck a braid of hair interwoven with threads of gold. Through signs, she made it clear to me that she wanted to put it round my neck, but that I had to remove the relic I was wearing. I refused to do so. Then mindful that they were Muslims and that an object revered by Christians might hurt their feelings, I weakened and agreed. I took off the little reliquary; but then I felt a qualm of conscience and at once seized it back again. Then came the sound of a cry, and the lamp went out, leaving me in darkness. There was another cry, and I recognized it as the howl of the demoniac Pacheco.

A hard dry hand seized hold of mine and dragged me out of bed. I had not undressed. I groped for my sword and found it, and followed where I was led. I walked for a long time in darkness. At last I emerged from the underground passage and in the light of the full moon I saw it was indeed Pacheco who had served as my guide.

We walked on a few paces more in the countryside. Pacheco seemed to succumb to his pains and rolled about in the dust. Another man appeared and signalled me to follow him. He took great strides, and as far as I could tell in the moonlight he was in no better health than the demoniac. Besides, there was something extraordinary about his dress, and he wore a bandeau round his forehead.

We reached the top of a mountain. My guide halted and said to me: "Stay here until daybreak. When the sun is risen, you will see the gallows on which Zoto's brothers

113

were hanged. You will find there a man alseep and you will wake him."

"Who are you?" I asked my guide.

"I", he replied, "am he who is not born and will not die, who walks and never rests, who remains awake and never sleeps, who once had a body but not any more. I am the Wandering Jew. Farewell. I am going to help Pacheco. We shall meet again some day."

The rising sun revealed in the distance the gallows built for Zoto's brothers. I walked for an hour across the scrub before reaching it. I found the gate open and a person lying between the two hanged men. I wakened him.

On seeing where he was, the stranger began to laugh, and said: "It has to be admitted that the person who studies the cabbala is liable to tiresome misapprehensions. The evil genii are able to take on so many forms, he does not know who he is dealing with."

"But," he added, "why do I have a rope round my neck. I thought it was a braid of hair I was wearing."

Then he noticed me and said: "Ah! you are very young for a cabbalist. But you too have a rope round your neck."

Indeed I did. I remembered that Emina had slipped round my neck a braid made of her own hair and that of her sister, and I did not know what to think of this.

The cabbalist stared at me for a few moments and then said: "No, you are not one of us, your name is Alphonse, your mother was a Gomelez. You are a captain in the Walloon Guards, a brave fellow but still a bit naive. Never mind, we must get away from here."

Then the stranger turned his head to his right shoulder and muttered a few words, as though giving an order under his breath.

"I have sent for my horses," he said, "and you will see them come."

Sure enough, we soon saw the arrival of a black servant riding a horse and leading another by its reins. The stranger mounted one, and I the other, and so we reached Venta Quemada.

"This is an inn," said my companion, "where a very cruel trick was played on me last night. Yet we must go inside. I have left some provisions there that will do us good."

We duly entered the inauspicious Venta and found in the dining room a table laid for a meal, with a pheasant pâté and two bottles of wine. We ate quite heartily, then we remounted our horses and took the road to the hermitage.

We got there an hour later, and the first thing I saw was Pacheco, stretched out in the middle of the room. He seemed to be at death's door, or at least his chest was racked with that dreadful rattle, the ultimate sign of imminent death. I wanted to speak to him, but he did not recognize me.

The hermit took some holy water and sprinkled it over the demoniac, saying: "Pacheco, Pacheco, in the name of your Redeemer, I command you to tell us what happened to you last night."

Pacheco shuddered, gave a long drawn-out howl, and began with these words:

The story of Pacheco

Father, you were in the chapel, singing litanies, when I heard a knock at the door and a bleating that sounded just like our white goat. So I thought it was her, and I thought that because I had forgotten to milk her, the poor beast was coming to remind me. I believed this all the more

115

readily since the same thing had actually happened a few days ago. So I came out of the hut and there I saw your white goat; she had her back to me, so I could see the swollen udder. I tried to grab hold of her in order to do her the service she was asking of me, but she slipped through my hands. And so she kept stopping and slipping away, until she led me to the edge of the precipice near your hermitage.

When we reached it, the white she-goat turned into a black billy-goat. This transformation terrified me, and I tried to run back to our house, but the black goat blocked my path, and then rearing up on his hind legs and staring at me with his blazing eyes, he instilled such fear in me that I was frozen to the spot.

Then the cursed goat began to butt me with his horns, driving me towards the precipice. When I was on the edge, he stopped to savour my mortal anguish. Finally he forced me over.

I thought I had been smashed to smithereens, but the goat reached the bottom of the precipice before me, and I landed on his back without incurring any injury.

New fears were not long in assailing me, for as soon as this cursed goat felt me on his back, he started to gallop in a strange way. He leapt from mountain to mountain in a single bound, jumping over the deepest valleys as though they were no more than ditches. Then we arrived at the gibbet for Zoto's brothers, who immediately came down from it. One of them sat astride the goat, and the other on my neck. We set off like streaked lightning, and I don't know how it could be, but I went as fast as the goat. The hanged man who was riding me felt that I was not going as fast as he would have liked. He picked up two scorpions as we ran, attached them to his heels and began to tear at my sides with the most peculiar barbarity. So we came to some vast caverns, which seemed to be inhabited, but everyone was fast asleep. We went into a stable. The two hanged men knelt before the goat that licked the tips of their noses. Then they shed their dreadful

countenance and appeared to me as two young Moorish ladies of astonishing beauty.

One of them picked up a lamp in one hand, gave the other to her young companion, and they disappeared down an underground passage. The black goat vanished into a hole in the rock...

Soon afterwards I saw a thin gaunt man who had a sign emblazoned on his forehead that looked rather like a cross. He came up to me and said: "Pacheco, Pacheco, in the name of your Redeemer, I command you to follow the two hanged men to where the young nobleman whom you have already met lies in bed, and to drag him out of this cavern. This I command you to do, and I shall give you the power to carry out my command."

I obeyed. I dragged out the young Alphonse, but I was no sooner out of the cavern than my torn sides caused me terrible pain. The man who had spoken to me inside the cave picked me up like a feather, brought me to your hermitage, where I have found some relief. But he came too late. The scorpions' poison has worked its way into my guts. I am dying.

Thereupon, the demoniac gave a dreadful howl and fell silent.

Then the hermit spoke, and said to me: "My son, you have heard his story. Is it possible that you have carnally conjoined with two demons? Come, make your confession, admit your guilt. Divine mercy is boundless. You do not reply? Could it be that sin has hardened your heart?"

After giving this a few moments' thought, I replied: "Father, this demoniac gentleman has seen some strange things. Perhaps his eyes have been tricked. The events that concern us are of the most extraordinary nature. We could never gather too much information about them. Here is a gentleman whom I had the honour of finding asleep beneath the gibbet. If he would tell us his adven-

ture, his account could not fail to be of great interest to us."

"Signor Alphonse," said the cabbalist, "people who, like me, take an interest in the occult sciences, cannot disclose everything. However, I shall try to satisfy your curiosity in so far as it lies within my power to do so, but not this evening. If you please, let us have supper and go to bed. Tomorrow we will be feeling more calm and collected."

The anchorite served us a frugal supper, after which everyone's only thought was of going to bed. The cabbalist claimed to have reasons for spending the night with the demonaic Pacheco, and I was sent to the chapel, as on that other occasion. My mossy bed was still there. I lay down on it. The hermit wished me good-night, and warned me that, for greater safety, he would lock the door after him.

I fell asleep and was woken by the midnight chimes of a bell.

Soon afterwards I heard a knock at the door and what sounded like the bleating of a goat. I took my sword, went to the door, and said in a firm voice: "If you are the devil, try to open this door, for the hermit has locked it."

The goat fell silent... I went back to bed and slept until the following day.

THE EIGHTH DAY

The hermit came to wake me. He sat down on my bed and said: "My child, last night evil spirits again assailed my poor hermitage. The stylites in the desert were not more exposed to Satan's malice. Nor do I know what to think of the man who came with you, and who claims to be a cabbalist. He has undertaken to cure Pacheco, and has actually done him some good, but he did not use the exorcisms prescribed by the rites of Our Holy Church. Come to my hut, we will have something to eat, and then we will ask him to tell us his story, which he promised us yesterday evening.

I got up and followed the hermit. I found that Pacheco's condition had indeed become more tolerable, and his face less hideous. He was still blind in one eye, but his tongue was no longer hanging out. He was not foaming at the mouth any more, and his one eye seemed less wild. I congratulated the cabbalist, who replied that this was just a very poor example of his expertise. Then the hermit brought our breakfast, which consisted of hot milk and chestnuts.

At the end of our meal the hermit said to me: "Ask this gentleman if he would kindly tell us his story. It sounds as though it should be interesting.

The cabbalist protested, saying that there were many things in his story we would not be able to understand. But after a moment's reflection he began with these words:

The cabbalist's story

In Spain I am known as Don Pedro de Uzeda, and it is under this name that I own a pretty castle that lies one league from here. But my real name is Rabbi Sadok Ben Mamoun, and I am Jewish. This is a rather dangerous admission to make in Spain, but my trust in your integrity aside, I warn you that it would not be very easy to cause me harm. The influence of the stars on my destiny began to manifest itself from the moment of my birth, and my father, who cast my horoscope, was overwhelmed with joy when he saw that I had come into the world simultaneously with the sun's entry into the sign of Virgo. To tell the truth, he had exercised all his skill so that this should happen, but he had not hoped to succeed to such a degree of accuracy. I have no need to tell you that my father, Mamoun, was the leading astrologer of his time. But knowledge of the constellations was the least of the sciences of which he had mastery, for he had pursued that of cabbalism to a level no rabbi before him had attained.

Four years after I came into the world, my father had a daughter, who was born under the sign of Gemini. Despite this difference between us, our education was the same. Even before I was twelve, and my sister eight, we already knew Hebrew, Chaldean, Aramaic, Samaritan, Coptic, Abyssinian, and several other dead or dying languages. Besides, we could, without the aid of a pencil, combine all the letters of a word in every way prescribed by the rules of the cabbala.

It was also at the end of my twelfth year that we were both most scrupulously confined, and so that nothing should belie the modesty of the sign under which I was born, we were given only virgin animals to eat, with care

taken to feed me with none but male animals, and my sister with none but female.

When I reached the age of sixteen, my father began to initiate us into the mysteries of the Sefiroth cabbala. First he placed in our hands the *Sefer Zohar*, or *Book of Splendour*, so called because the light it sheds so dazzles the eye of understanding, it defies comprehension. Then we studied the *Sifra da-Zeni'utha*, or *Book of Concealment*, the clearest passage in which may pass for an enigma. Finally we came to the *Idra Rabba* and *Idra Zutta* – that is, the *Greater* and *Lesser Sanhedrin*. These are dialogues in which Rabbi Simeon, son of Yohai, author of two other works, simplifying his style to the level of conversation, pretends to teach his friends the simplest things, and yet reveals to them the most astounding mysteries; or rather, all the revelations that come to us directly from the Prophet Elijah, who secretly left the heavenly abode and joined us here below under the assumed name of Rabbi Abba.

Those who are not initiates may think they can acquire some idea of all these divine scriptures from the Latin translation published with the original Chaldean in the year 1684 in a small town in Germany called Frankfurt? But we laugh at the presumption of those who imagine that in order to read, the physical organs of sight are sufficient. They might indeed suffice for the purposes of certain modern languages, but in Hebrew each letter is a number, each word a scholarly combination, each sentence a dreadful formula that, if properly pronounced with all the right breathings and stresses, could level mountains and make rivers run dry. You well know that Adonai created the world through the Word, then made himself the Word.

The Word strikes the air and the mind, it acts on the senses and on the soul. Although uninitiated, you can readily conclude from this that it must be the true intermediary between matter and intelligences of every order. All I can tell you is that every day we acquired not only new knowledge but also a new power, and if we dared

not make use of it, at least we had the pleasure of sensing our strength and of being inwardly convinced of it.

But our cabbalistic joys were soon cut short by the most woeful of events.

Every day my sister and I noticed that my father, Mamoun, was losing his strength. He seemed a pure spirit that had assumed human form only to be discernible to the unrefined senses of terrestrial beings.

At last came the day when he summoned us to his study. He looked so venerable and divine that we both instinctively knelt. He let us remain in this position, and pointing to an hour-glass, he said: "Before the sands run out, I shall be no more. Do not let a single word I say escape you.

"My son, I address you first: for you I intend heavenly brides, daughters of Solomon and the Queen of Sheba. They were destined to be born but mere mortals. But Solomon having revealed to the Queen the great name of He who is, the Queen uttered it at the very moment of giving birth. The spirits of the Grand Orient hastened to her and caught the twin girls before they had touched the impure sojourn called Earth. They bore them to the sphere of the daughters of Elohim, where they received the gift of immortality, with the power to bestow it upon him they would choose as their shared husband. It was these two ineffable brides that their father had in mind in his *Shir ha-Shirim*, or *Song of Songs*. Study this divine epithalamium of nine verses in nine.

"For you, my daughter, I intend an even more splendid marriage. The two Thamim, whom the Greeks knew by the name of the Dioscuri, the Phoenicians by that of the Kabires – in a word, the heavenly Gemini. They will be your grooms... what am I saying... your tender heart, I fear that a mortal... The sands run out... I die."

With these words my father faded away, and we found in the place where he had been a few light and shining ashes. I gathered up these precious remains. I put them in

an urn, and placed them in the inner tabernacle of our house, under the wings of the cherubim.

You can well imagine that the hope of enjoying immortality and of possessing two heavenly brides renewed my enthusiasm for the cabbalistic sciences, but it was years before I would dare to raise myself to such heights, and I contented myself with subjecting to my conjurations some few spirits of the eighteenth order. However, gradually growing bolder, last year I attempted an exercise on the first verses of *Shir ha-Shirim*. Hardly had I completed a single line when a dreadful noise was heard, and my castle seemed to crumble to its foundations. This did not frighten me at all. On the contrary, I concluded that my calculation was correct. I moved on to the second line. When that was complete, a lamp I had on my table jumped down on to the floor, and with a few leaps and bounds came to rest in front of a large mirror tucked away in my bedroom. I looked in the mirror and saw the tips of two very pretty lady's feet, then two other little feet. I had the audacity to imagine that these charming feet belonged to the celestial daughters of Solomon, but I did not think I ought to pursue my exercises any further.

I returned to them the following night and saw the four little feet up to the ankles. Then the next night, I saw the legs up to the knees, but the sun left the sign of Virgo and I was obliged to stop.

When the sun had entered the sign of Gemini, my sister carried out exercises similar to mine, and had a no less extraordinary vision, which I will not describe to you, since it has no bearing on my story.

This year I was preparing to start again, when I learned that a famous practitioner of the art was to pass by Cordoba. A discussion I had with my sister about him persuaded me to go and see him on his way through. I left a little late and that day got no further than Venta Quemada. I found this inn deserted for fear of ghosts, but since I do not fear them, I made myself comfortable in the dining room, and ordered little Nemrael to bring me

some supper. This Nemrael is a genie of very contemptible character, whom I employ to carry out such tasks. He went to Andujar, where a Benedictine prior was staying the night, snatched away his supper without so much as a by-your-leave, and brought it to me. It consisted of that pheasant pâté you were so pleased to find the following morning. As for myself, I was tired and hardly touched it. I sent Nemrael home to my sister, and went to bed.

In the middle of the night I was awakened by a bell that rang twelve times. After this prelude I expected to see some ghost and was even preparing to dismiss it, because in general they are bothersome and annoying. This was my frame of mind when I saw a strong light on a table in the middle of the room, and then a little sky-blue rabbi appeared on it, swaying in front of a lectern, as rabbis do when they pray. He stood no more than a foot high, and not only were his clothes blue but even his face, his beard, his lectern and his book. I soon realized that this was no ghost but a genie of the twenty-seventh order. I did not know his name and I was not at all familiar with him. However, I used a formula that has some power over all spirits in general.

Then the little sky-blue rabbi turned to me and said: "You began your calculations backwards, and that is why the daughters of Solomon appeared to you feet first. Begin with the last verses, and first find the names of the two celestial beauties."

Having spoken thus, the little rabbi vanished.

What he had told me contradicted all the rules of the cabbala. Yet I was weak and followed his advice. I set to work on the last verses of *Shir ha-Shirim*, and seeking the names of the two immortals, I found Emina and Zibedde. I was very surprised. However, I began the evocations. Then the earth shook terrifyingly beneath my feet. I thought I saw the skies collapse on my head, and I lost consciousness.

When I came to, I found myself in a place brilliant with light, in the arms of some young men more handsome than angels.

One of them said to me: "Son of Adam, recover your senses, you are here in the home of those who are not dead. We are governed by the patriarch Enoch, who walked before Elohim, and who was borne up from Earth. The Prophet Elijah is our high-priest, and his chariot will always be at your service whenever you want to visit some planet. As for us, we are grigori, born of the congress between the sons of Elohim and the daughters of men. You will also see among us some nefilim, but in small number. Come, we are going to present you to our sovereign."

I followed them and came to the foot of the throne on which Enoch was seated. Never would I be able to withstand the fire that came from his eyes, and I dared not raise mine higher than his beard, which was rather like that pale light we see around the moon on damp nights.

I feared that my ears would not be able to endure the sound of his voice, but his voice was softer than that of heavenly organs. Yet he made it softer still to say to me: "Son of Adam, your brides are about to be brought to you."

Thereupon I saw the Prophet Elijah, leading by the hand two beauties whose charms defy human conception. They were charms so delicate that their souls were visible through them, and the fire of their passions was clearly discernible as it flowed in their veins and mingled with their blood. Behind them, two nefilim carried a tripod made of a metal as superior to gold as the latter is more precious than lead. My hands were placed in the hands of Solomon's daughters, and round my neck was hung a braid woven of their hair. A bright pure flame, which then issued from the tripod, consumed in an instant all that was mortal in me.

We were led to a couch, resplendent with glory and ablaze with love. A large window that communicated

with the third heaven was thrown open, and the angels' choruses brought my rapture to a climax…

But let me tell you, the next day I woke up under the Los Hernanos gallows, lying by those two vile corpses. I concluded that I had been dealing with some very wicked spirits with whose character I am not very well acquainted. Indeed, I greatly fear this whole episode might prejudice my relations with the true daughters of Solomon, of whom I saw only the tips of their feet.

"Poor blind fool," said the hermit, "and what do you regret? All is but illusion in your baneful art. The cursed succubi that duped you have inflicted the most dreadful torments on wretched Pacheco, and doubtless a similar fate awaits this young gentleman who, with a grievous hardening of his heart, refuses to confess his sins. Alphonse, Alphonse my son, repent, there is still time!"

This persistence of the hermit in demanding of me confessions I did not want to make greatly displeased me. I replied rather coldly, saying that I respected his holy exhortations but that I conducted myself in accordance only with the laws of honour. Then the conversation turned to other matters.

The cabbalist said to me: "Signor Alphonse, since you are being pursued by the Inquisition, it is very important that you find a safe refuge. I offer you my castle. There you will see my sister Rebecca, who is almost as beautiful as she is learned. Yes, come, you are a descendant of the Gomelez, and this bloodline has a claim on our interest."

I looked at the hermit to read in his eyes what he thought of this proposition.

The cabbalist seemed to divine my thoughts, and addressing the hermit, said to him: "Father, I know you better than you think. You can do much through faith. My ways are not so holy, but they are not diabolical. Come to my house too, with Pacheco, whose cure I will complete."

Before replying, the hermit began to pray, then after a moment's meditation, he came to us with a cheerful look on his face and said that he was ready to go with us.

The cabbalist turned to his right shoulder and gave an order for the horses to be brought. A moment later we saw two at the hermitage door, together with two mules, which the hermit and the demoniac mounted. Although from what Ben Mamoun had told us the castle was a day's journey distant, we were there in less than an hour.

On the way Ben Mamoun talked to me a great deal about his learned sister, and I was expecting to see some black-haired Medea, with a wand in her hand, muttering spells, but this conception of her was completely false. The amiable Rebecca who welcomed us at the castle entrance was the kindest and most appealing blonde anyone could possibly imagine. Her lovely golden hair fell naturally to her shoulders and she was nonchalantly dressed in a white robe – although the clasps that fastened it were priceless. Her outward appearance proclaimed a person who never gave any thought to what she wore, but it would have been difficult to improve upon the result by giving it more.

Rebecca threw her arms round her brother's neck and said to him: "How you worried me! I always had news of you, except for the first night. So what happened to you?"

"I shall tell the whole story," replied Ben Mamoun. "For now, think only of welcoming the guests I have brought you: this is the hermit from the valley, and this young man is a Gomelez."

Rebecca looked at the hermit with a fair degree of indifference, but when she glanced at me, she seemed to blush and said rather sadly: "I hope for the sake of your happiness that you are not one of us."

We went inside, and the drawbridge was immediately raised behind us. The castle was quite enormous, and everything seemed to be in the utmost good order. Yet we saw only two servants: a young mulatto, and a mulatto woman of the same age. Ben Mamoun led us first

to his library. It was a little rotunda that served also as a dining room. The mulatto came to lay the cloth, brought an *olla podrida* and four place settings, for the lovely Rebecca did not sit down at table with us. The hermit ate more than usual and also seemed to become more human, while Pacheco, still blind in one eye, seemed no longer to suffer the effects of his possession. However, he was grave and silent. Ben Mamoun ate with considerable appetite, but he seemed preoccupied and confessed to us that his adventure of the day before had given him much to think about.

As soon as we had risen from table, he said to us: "My dear guests, here are books to keep you amused, and my black servant will be only too willing to be of service to you in any way. But allow me to retire with my sister to attend to an important task. You will not see us again until dinner-time tomorrow."

Ben Mamoun duly retired and left us masters of the house, as it were.

The hermit took from the library a *Lives of the Desert Fathers*, and instructed Pacheco to read him some chapters from it. As for myself, I went out on to the terrace that overlooked a precipice, at the bottom of which flowed a river that was out of sight but the roar of which could be heard. Dreary as this landscape might have seemed, it was with extreme pleasure that I began to contemplate it, or rather to surrender myself to the feelings the sight of it inspired in me. It was not melancholy, it was almost an exhaustion of all my faculties, brought about by the cruel excitements to which I had been victim in the last few days. Pondering on what had happened to me and not being able to make any sense of it, I ended up not daring to give the matter any more thought, for fear of losing my wits. The hope of spending a few quiet days in the Uzeda castle was for the present a most attractive prospect. I left the terrace and came back into the library.

Then the young mulatto served us a light meal of dried fruits and cold meats, which included no unclean meat.

Afterwards we parted company. The hermit and Pacheco were shown to one room, I to another.

I went to bed and fell asleep.

But soon after, I was awakened by the lovely Rebecca, who said to me: "Signor Alphonse, forgive me for making so bold as to interrupt your sleep. I have just come from my brother. We have performed the most dreadful conjurations in order to acquaint ourselves with the two spirits with which he had dealings at the Venta, but we have had no success. We believe he was tricked by baalim, over whom we have no power. Yet the realm of Enoch really is just as he saw it. This is all of great importance to us, and I beg you to tell us what you know."

Having said this, Rebecca sat down on my bed, but she did so without ulterior motive, and seemed solely concerned with the information she was asking of me. However, she did not obtain it, and I contented myself with telling her that I had given my word of honour never to speak of the matter.

"But Signor Alphonse," said Rebecca, "how can you imagine that a pledge of honour given to two demons could be binding upon you? Now, we know these are two female demons, and their names are Emina and Zibedde. But we are not very well acquainted with the nature of these demons, because in our science, as in every other, one cannot know everything."

I stood by my refusal, and begged this beautiful woman not to say any more about it.

Then she looked at me with a kind of benevolence and said: "How fortunate you are to have principles of virtue according to which you guide all your actions and preserve a clear conscience! How different is our own fate! We wanted to see what it is not granted to men to see, and to know what their reason cannot comprehend. I was not meant for such sublime knowledge. What do I care for a futile authority over demons! I would have been well content to rule the heart of a husband. It is my father's wish, I must submit to my destiny."

As she spoke these words, Rebecca drew out her handkerchief and seemed to hide a few tears, then she added: "Signor Alphonse, allow me to return tomorrow at the same time, and to make further efforts to overcome your obstinacy, or as you put it, this great attachment to your word. Soon the sun will enter the sign of Virgo, then the moment will have passed and events will take their course."

As she took her leave of me, Rebecca gave my hand a friendly squeeze and seemed to return reluctantly to her cabbalistic exercises.

THE NINTH DAY

I woke earlier than usual and went out on the terrace for a breath of fresh air before the sun had made the atmosphere too hot. The air was still. Even the river seemed to roar with less fury, so that the concert of birdsong was audible.

I heard in the distance the strains of some very lively music that seemed to set the mountain spinning. They soon became more distinct, and I caught sight of a cheerful band of gypsies advancing in time with the music, singing and accompanying themselves on their *sonajas* and *cascarras*. They pitched their temporary camp near the terrace and gave me the opportunity to note the elegance of their clothes and bearing. I assumed these were the very gypsy robbers under whose protection the keeper of the Venta de Cardeñas had placed himself, according to what the hermit had told me. But they seemed too gracious for brigands. While I observed them, they set up their tents, put their *olles* on the fire, hung up their children's cradles in the branches of nearby trees. And when all these preparations were completed, they gave themselves up once more to the pleasures attendant on their vagabond life, of which the greatest in their eyes is idleness.

The chieftain's tent was distinguished from the others not only by the pole with a large silver knob on it that was planted outside but also because it was in good condition, and even decorated with a costly fringe, which is not commonly seen on gypsy tents. But imagine my surprise on seeing the tent open and my two cousins emerge, in that elegant costume called in Spain *a la gitana maja*. They came up to the foot of the terrace, but without appearing to notice me. Then they called their companions and began to dance the famous polo, to the following words:

Cuando me Paco me alce
Las palmas para bailar
Se me pone el cuerpecito
Como hecho de mazapan. Etc.

If loving Emina and gentle Zibedde had turned my head when dressed in their Moorish simars, they delighted me no less in this new costume. Only I thought they had an artful mocking look about them – one not, in truth, unbecoming to these fortune-tellers – but which seemed to be a sign they were thinking of playing some new trick on me by showing themselves in this new guise. However, they appeared to take no interest in me, and moved away when their dance was over.

I returned to the library, where I found on the table a large volume written in Gothic characters, the title of which was *Strange Tales* by Happelius. The book was open, and the page seemed to have been deliberately turned down at the beginning of a chapter, where I read the following story:

The story of Thibaud de la Jacquière

Once upon a time, in the French town of Lyons, situated on the Rhône, there lived a very rich merchant, called Jacques de la Jacquière. To be more accurate, he did not take the name of La Jacquière until he had quit trade and become Provost of the city, an office the people of Lyons

grant only to men with a large fortune and an unblemished reputation. Such a man was the good Provost de la Jacquière: charitable to the poor and a benefactor to monks and other religious men, who are the true poor, according to the Lord.

But the Provost's only son, Messire Thibaud de la Jacquière, ensign of the King's men-at-arms, was not such a man. A real ruffian rather, with a fondness for duelling, a great seducer of young girls, player of dice, breaker of windows, lantern-shatterer, swearer and blasphemer, who time after time stopped wealthy citizens in the street in order to swap his old coat for a brand-new one, and his worn felt hat for a better one. So much so that Messire Thibaud was the sole topic of conversation, whether in Paris, or at Blois, Fontainebleau, or any of the King's other residences. Now, it happened that our good lord of blessed memory François I finally lost patience with the young junior officer's excesses, and sent him home to Lyons, to do penance in the house of his father, the good Provost de la Jacquière, who was then living on the corner of the Place de Bellecour, at the top of the rue St-Ramond.

The young Thibaud was welcomed back to the paternal home with as much joy as if he had come bearing all of Rome's indulgences. Not only was the fatted calf slain for him but the Provost held a banquet for his friends that cost more gold écus than there were guests. More than that: a toast was drunk to the young fellow's health and everyone wished him wisdom and repentance.

But these charitable wishes displeased him. He took a gold cup, filled it with wine and said: "As Satan is my witness, with this wine I pledge my body and soul to the devil if ever I become a better man than I am now."

These appalling words made the hairs on the guests' heads stand on end. They crossed themselves, and a few rose from the table.

Messire Thibaud also rose, and went out to take the air on the Place de Bellecour, where he came across two of

his former companions, both of them soldiers of the same stamp as himself. He embraced them, took them home with him and had flagons aplenty brought to them, without sparing another thought for his father and all the guests.

What Thibaud had done the day of his arrival, he did the next day, and every day thereafter, with the result that the good Provost was broken-hearted. He decided to commend himself to his patron, St Jacques, and brought before the saint's image a candle that weighed ten pounds, decorated with two gold rings worth five marks apiece. But as the Provost was placing the candle on the altar, he dropped it and knocked over a silver lamp that was burning in front of the saint. The Provost had had this candle made for another occasion, but having nothing closer to his heart than the spiritual conversion of his son, he joyfully made an offering of it. However, when he saw the fallen candle and the upset lamp, he took these as a bad omen and returned sadly to his house.

That same day Messire Thibaud again entertained his friends. They swigged back many a flagon, and then when it was already very late and quite dark, they went out to take the air on the Place de Bellecour. And once outside, all three linked arms and swaggered about, in the manner of soldiers who think by so doing to attract the attention of young girls. But on this occasion they achieved nothing, for no girl or woman passed by, and none could be seen either at the windows, because it was a very dark night, as I have already mentioned. So it was that young Thibaud, raising his voice and swearing his customary oath, said: "As Satan is my witness, I pledge my body and soul to the devil that if the great she-devil his daughter were to pass by, I would woo her, so hot has the wine made my blood."

These words offended Thibaud's two friends, who were not such great sinners as he was. And one of them said to him: "My friend Thibaud, remember that the devil is the eternal enemy of mankind and does us harm enough

without any invitation, and without his name being invoked."

To which Thibaud replied: "I shall do what I have said."

At this point the three debauchees saw emerging from a nearby street a veiled young woman with a pleasing figure, in the first flush of youth. A little black servant ran after her. He tripped, fell flat on his face, and broke his lantern. The young lady seemed very frightened and did not know what to do. Then Messire Thibaud went up to her as politely as he could, and offered his arm to her, to accompany her home. The damsel in distress accepted, after some demurring, and Messire Thibaud, turning to his friends, said to them in a lowered voice: "There, you see the one whom I invoked did not keep me waiting. So I wish you good evening."

The two friends realized what he meant, and took leave of him, laughing and wishing him happiness and joy.

Then Thibaud gave his arm to the lovely lady, and the little black fellow, whose lantern had gone out, walked on ahead of them. The young woman seemed at first so distressed she could hardly stand, but she gradually over-came her apprehensions and leaned more freely on her escort's arm. Sometimes she missed her footing and even gripped his arm to save herself from falling. Then Thibaud, wanting to keep her close, would press his arm against his breast, though he did it with considerable discretion so as not to startle his quarry.

So they walked and walked, for such a long time that in the end it seemed to Thibaud they had lost their way in the streets of Lyons. But he was very glad of it, for he thought he would all the more easily have his way with the lovely lost lady. However, wanting to know first with whom he was dealing, he asked her to sit on a stone bench he had caught sight of near a doorway. She agreed, and he sat down next to her. Then he took one of her hands in a gentlemanly manner, and said to her with much feeling: "Lovely wandering star, since my star led me to

meet you in the night, be kind enough to tell me who you are and where you live."

The young woman seemed at first very shy, gradually gained confidence, and replied in these terms:

The story of the fair maiden of Châtel de Sombre

My name is Orlandine, at least that is what the few people who live with me at Châtel de Sombre, in the Pyrenees, call me. There I saw no human being, apart from my governess, who was deaf; a serving-woman who stammered so badly she could be termed mute; and an old gate-keeper who was blind.

This gate-keeper did not have much to do, since he opened the gate but once a year, and then to a gentleman who came only to take me by the chin and to speak to my duenna in Biscayan dialect, which I do not understand. Happily, I had already learned to speak when I was shut away in Châtel de Sombre, for I would certainly never have learned from my two prison companions. As far as the gate-keeper was concerned, I saw him only when he came to pass our meals through the bars on our only window. Truth to tell, my deaf governess often bellowed in my ears some moral precept or other, but I could make as little sense of them as if I had been as deaf as she was, for she spoke to me of the duties of marriage and did not tell me what a marriage was. She spoke to me similarly

of many things she would not explain. Often too my stuttering maidservant would strive to tell me some story, which she assured me was extremely funny. But since she could never get beyond the second sentence, she was forced to give up, and would walk off stammering apologies, acquitting herself no better with these than in telling her story.

I told you we had but a single window. That is to say, there was only one that looked out on the castle court-yard. The others overlooked another courtyard, planted with a few trees and so able to pass for a garden, and to which there was no access except through my bedroom. I grew flowers in it, and it was my sole diversion.

I tell a lie, I had another, just as innocent. It was a large mirror in which I would go and look at myself as soon as I got up, not to say the instant I jumped out of bed. My governess – like me, still in her nightclothes – would come and gaze at herself too, and I would amuse myself by comparing my figure with hers. I would also indulge in this entertainment before going to bed, and when my governess was already asleep. Sometimes I fancied that I saw in my mirror a companion of my own age, who responded to my gestures and shared my feelings. The more I surrendered myself to this illusion, the more pleasure I took in the game.

I told you there was a gentleman who came once a year to take me by the chin and to speak Basque with my governess. One day, instead of taking me by the chin, this gentleman took me by the hand and led me to a closed carriage, and shut me up inside it with my governess. It is no exaggeration to say I was shut up, for the only daylight in the carriage came from above. We were not let out until the third day, or rather the third night – it was at least very late in the evening.

A man opened the door and said to us: "Here you are, on the Place de Bellecour, at the top of rue St-Ramond, and here is the house of Provost de la Jacquière. Where would you like to be taken?"

"Turn into the first carriage gateway after the Provost's," replied my governess.

At this point young Thibaud grew very attentive, for he was indeed the neighbour of a gentleman called Sire de Sombre, reputed to be of a jealous disposition, who had often boasted in Thibaud's presence that one day he would show that a man could have a faithful wife; he boasted too of having a young maiden reared in his castle, who was to become his wife and prove the truth of what he said. Young Thibaud had not realized she was in Lyons, and was delighted to have her in his clutches.

Meanwhile, Orlandine continued with these words:

So we entered a carriage gateway, and I was taken up to some large and splendid rooms, and then from there, up a spiral staircase to a tower from which it seemed to me one would have had a view over the whole city of Lyons, had it been light. But even during the day one would not have seen anything, for the windows were shrouded with a very heavy green cloth. However, the tower was lit by a beautiful crystal chandelier mounted in enamel. My duenna sat me on a chair, gave me her rosary to keep me amused, and departed, double- and triple-locking the door behind her.

Once I was alone, I threw down my rosary, took the scissors I had on my belt, and cut a vent in the green cloth covering the windows. Then I saw another window very close by me, and through this window I saw a very brightly lit room, in which three young gentlemen and three young girls – more handsome, more gay than anything imaginable – were having supper. They were singing, drinking, laughing, embracing each other. Sometimes they even took each other by the chin, but quite differently from the gentleman at Châtel de Sombre, albeit he came for that sole purpose. Moreover, these gentlemen and young ladies were gradually shed-

ding their clothes, as I used to in the evenings in front of my large mirror, and in truth it suited them just as well as me, and not as it did my old duenna.

At this point Messire Thibaud realized that she was describing a supper he had had the day before with his two friends. He slipped his arm round Orlandine's plump and supple waist and clasped her to his chest.

"Yes," she said, "that is exactly what those young gentlemen were doing. Really, it seemed to me they all loved each other very much. Yet I heard one of these young fellows say he was a better lover than the others. 'No, I am, I am!' said the other two. 'He is.' 'No, he is,' said the young girls. Then the one who had boasted of being the best lover thought of a remarkable way to prove his claim."

Thibaud, who recalled what had happened at the supper, now almost choked with laughter.

"Well then," he said, "lovely Orlandine, what was it the young man thought of?"

"Ah," said Orlandine, "do not laugh, sir, I assure you it was very clever, and I was paying close attention, when I heard the door open. I immediately returned to my rosary and my duenna came in.

"She took me by the hand again, without saying a word, and ushered me into a carriage, which was not closed as the first had been, and I would certainly have been able to see the town from this one, but it was after dark and I saw only that we travelled some distance, some considerable distance – so far in fact that we eventually came to the countryside on the very edge of town. We stopped at the last house on the outskirts. It was just a hut from the outside, and it even had a thatched roof, but it was pretty inside, as you will see, if the little black fellow knows his way, for I see he has found some light and is relighting his lantern."

Here, Orlandine came to the end of her story.

Messire Thibaud kissed her hand and said: "Lovely lost lady, do you live all alone in this pretty house, may I ask?"

"All alone," said the beautiful young woman, "together with this little black fellow and my governess. But I do not think she will come back to the house this evening. The gentleman who used to take me by the chin sent word I was to join him, with my governess, at the house of one of his sisters, but that he could not send his carriage which had gone to fetch a priest. So we were making our way there on foot. Someone stopped us to tell me he thought me pretty. My duenna, who is deaf, took it that he was insulting me and answered him in kind. Other people came up and joined in the rumpus. I was frightened and started to run. The little black fellow ran after me. He fell, his lantern broke, and it was then, good sir, that happily for me I met you."

Charmed by the innocence of this account, Messire Thibaud was about to reply with some pretty speech when the little black fellow came up with his lighted lantern, illuminating Thibaud's face. Orlandine cried: "What's this I see? You are the young gentleman who thought up the clever idea!"

"The very same," said Thibaud, "and I assure you that what I did then is as nothing compared with what a charming honest young lady could expect of me. For those girls I was with were anything but that."

"You seemed to love all three well enough," said Orlandine.

"The fact is, I loved none of them," said Thibaud.

And so he talked, and so she talked, and walking and chatting, they came to the edge of town, to an isolated cottage on the outskirts. The little black fellow opened the door with a key he carried on his belt.

There was certainly nothing cottage-like about the inside of the house. One's eyes were met with beautiful Flemish tapestries depicting characters so finely worked and well portrayed they seemed alive; candelabras of pure solid silver; costly cabinets of ivory and ebony; armchairs

in Genoese velvet trimmed with gold tassels; and a bed covered with Venetian moiré. But Messire Thibaud dwelt on none of this. He had eyes only for Orlandine, and would have dearly liked to have his affair concluded.

At this point the little black fellow came to lay the table, and Thibaud noticed that it was not a child as he had first thought, but rather an old dwarf, black as black, with a hideous face. However, the little man brought something that was not at all unattractive: a vermeil bowl containing four steaming partridges that looked appetizing and well cooked, and under his arm he had a carafe of hippocras. Thibaud had no sooner eaten and drunk than it seemed to him that a liquid fire was running through his veins. As for Orlandine, she ate little and stared often at her guest, now with a tender and naive gaze, now with eyes so full of roguishness that the young man was almost unnerved by it.

Eventually the little black fellow came to clear the table. Then Orlandine took Thibaud by the hand and said to him: "Handsome sir, how would you like us to spend the evening?"

Thibaud did not know what to say.

"I have an idea," said Orlandine. "Here is a big mirror. Let's play in front of it, as I used to at Châtel de Sombre. It amused me to see how different in shape my governess was from me. Now I want to know if I am not different in shape from you.

"Orlandine placed their chairs in front of the mirror and afterwards unlaced Thibaud's ruff, saying to him: "You neck is more or less like mine. Your shoulders too, but what a difference in our breasts! Mine was like that last year, but I have filled out so much I don't recognize myself any more. Well, take off your belt! Undo your doublet! Why so much lacing?"

Unable to restrain himself a minute longer, Thibaud carried Orlandine to the Venetian moiré bed and thought himself the happiest of men...

But he soon changed his mind, for he felt what seemed like claws digging into his back.

"Orlandine, Orlandine," he cried, "what is the meaning of this?"

Orlandine was no more. Thibaud saw in her stead only a horrible assemblage of strange and hideous forms.

"I am not Orlandine," said the monster in a dreadful voice. "I am Beelzebub, and you will see tomorrow what body I have animated in order to seduce you."

Thibaud tried to invoke the name of Jesus, but Satan, who guessed his intention, caught him by the throat with his teeth and prevented him from uttering that holy name.

The next morning some peasants on their way to sell their vegetables at Lyons market heard moans coming from a derelict cottage that stood by the roadside and was used as a rubbish dump. They went inside and found Thibaud lying on top of a semi-putrefied corpse. They lifted him up and laid him across their baskets, and so they carried him to the Provost of Lyons... La Jacquière, poor man, recognized his son.

Young Thibaud was put to bed. Soon after, he seemed to regain his senses somewhat, and in a weak and almost unintelligible voice, he said : "Open the door to the holy hermit! Open the door to the holy hermit!"

At first no one understood what he was saying. Finally someone opened the door and ushered in a venerable monk, who asked to be left alone with Thibaud. He commanded obedience, and the door was closed on them. For a long time the sound of the monk's exhortations was audible, to which Thibaud replied in a firm voice: "Yes, father, I repent, and I trust in the mercy of God."

Eventually nothing more was heard and it was thought someone should go in. The hermit had disappeared, and Thibaud was found dead with a crucifix in his hands.

I had no sooner reached the end of this story than the cabbalist came in, and seemed to want to read in my eyes

what impression my reading had made upon me. The truth is that it had greatly impressed me, but I did not want to let him see this, and I retired to my room. There I reflected upon everything that had happened to me, and I almost came to believe that in order to deceive me demons had instilled life into the bodies of hanged men, and that I was another La Jacquière. The gong sounded for dinner. The cabbalist did not join us. To me, everyone seemed preoccupied, because I was myself preoccupied.

After dinner Rebecca took me aside and said: "Alphonse, this morning you watched very attentively as the gypsies danced at the foot of this terrace. Did you see in them some striking resemblance to anyone else?"

I asked her not to question me on this matter.

She replied: "Good sir, your discretion, I see, is unfailing. Happy the person who can find a confidant such as you. Our secrets are of a kind that are known only to people not at all like you, yet we have need of you. My brother would like you to go to the gypsy camp, and even spend a few days there. He thinks you will learn something about what happened at the Venta, which will be of as much interest to you as to him. Here are the keys to a gate at the foot of the terrace that will let you out onto the country road, near where the gypsies have pitched their camp. Do not refuse us this service: observe the chieftain's daughters, and try to cast some light on a mystery that troubles our people and may perhaps decide our fate. Ah! if only my life had been that of an ordinary mortal! I would have been more at home than in these alien spheres to which I have been transported against my will."

After she had spoken, Rebecca moved away. She seemed upset. I dressed hurriedly. I threw my cape over my shoulders, and picked up my sword. Then passing through the terrace gate, I went out into the countryside towards the gypsy tents.

I saw the leader of the band from a long way off. He was seated between two young girls who seemed to me

to share some resemblance with my cousins. But they went back inside the tent before I had time to get a good look at them. The old chieftain came towards me and said slyly: "Are you aware, noble sir, that you amongst a band of people who are ill spoken of in this area? Are you not at all afraid of us?"

At that word "afraid", I had placed my hand on the hilt of my sword. But the gypsy held out his hand and said in a friendly manner: "Forgive me, noble sir, I did not mean to offend you. So far was that from my intention, I would even beg you to spend a few days with us. Come into my tent. Being the best we have, it will be yours."

I needed no persuading. He introduced me to his two daughters, but to my great surprise I no longer saw in them any likeness to my cousins.

We strolled around the camp until someone came to tell us supper was served. Places were set beneath a tree with dense foliage. The food was good, especially the game, and the wine delicious.

Seeing the chieftain was chatting freely, I expressed my desire to know more about him. Without further ado, he told me his story. His name was Avadoro...

A gypsy came and interrupted us. After he had spoken in private with his chieftain, the latter said to me: "We cannot stay here. Tomorrow, at first light, we will leave this place."

We then went our separate ways back to our tents. My sleep was not interrupted as it had been the previous night.

THE TENTH DAY

We were mounted long before dawn, and rode deep into the desolate valleys of the Sierra Morena. At sunrise we were on a high peak from where I could see the course of the Guadalquivir and further in the distance the Los Hermanos gibbet. This view made me shiver, reminding me of a night of delicious pleasure and the horrors that followed upon my waking. We came down from this peak into quite a charming but very lonely valley, where we were to halt awhile. We pitched camp and ate hastily. And then, I don't know why, I wanted to get a closer look at the gibbet again, and see if Zoto's brothers were there. I took my gun. Being practised at getting my bearings, I easily found the road, and it did not take me long to reach that sinister enclosure. The gate was open. There lay the two cadavers stretched out on the ground, and between them a young girl, whom I recognized as Rebecca.

I woke her as gently as I could. However, the shock, which I could not entirely spare her, put her in a terrible state. She fell into convulsions, wept, fainted. I took her in my arms and carried her to a nearby spring. I splashed water on her face and gradually brought her round. I would never have dared ask her how she came to this gallows, but it was she who spoke first.

"I knew from the start", she said, "that your discretion would prove disastrous for us. You would not tell us your story, and I, like you, have fallen victim to those cursed vampires whose hateful tricks have in an instant reduced to nothing the lengthy precautions my father took to assure me of immortality. I cannot yet bring myself to believe the horrors of last night. Yet I am going to try to recall them and tell you what happened. But you will not understand unless I pick up the story of my life at an earlier point.

The story of Rebecca

My brother told you some of my story when he told you his. My father had intended him to be the husband of the Queen of Sheba's two daughters, and he wanted me to marry the two presiding spirits of the constellation of Gemini. Flattered by the alliance promised to him, my brother's enthusiasm for the cabbalist sciences intensified. It was the opposite with me. The idea of marrying two such spirits struck me as terrifying. The very thought of it was so disturbing I could not manage two lines of cabbala. Every day I would put off working at it to the next day, until in the end I had forgotten an art as difficult as it is dangerous.

It was not long before my brother noticed my negligence and bitterly reproached me for it. He threatened to complain to my father about me. I begged him to spare me this. He promised to wait until the following Saturday. But as I still had done nothing by then, he came to my room at midnight, woke me, and told me that he was going to summon up the ghost of my father, the fearsome Mamoun. I flung myself at his knees. He was unmoved. I heard him utter the dread formula invented long ago by the Witch of Endor. At once my father appeared, seated on an ivory throne. In his eye was the threat of death, and I feared I would not survive the first word that came from his mouth. Yet he spoke, God of Abraham, how he spoke! He dared to utter such dreadful curses. I shall not repeat what he said...

At this point the young Jewess buried her face in her hands and seemed to quake at the very thought of this cruel

scene. Finally she recovered herself, and continued in these terms:

I did not hear the last of my father's words. I had fainted before he finished. When I regained consciousness, I saw my brother handing me *The Book of Sefiroth*. I thought I would faint again, but I had to bow to necessity. My brother, who quite rightly suspected he would have to take me back to first principles, had the patience to help me gradually call them back to mind. I began with the composition of syllables, then went on to words and phrases. In the end I developed a passion for this sublime science. I would spend all night long in the study that had served as my father's observatory, and I would go to bed when daylight made it impossible to continue my work. By then I would be ready to drop for want of sleep. My mulatto maidservant Zulica would undress me almost without my noticing. I would sleep a few hours and then return to these pursuits for which I was not meant, as you will see.

You know Zulica, and you will have noticed her charms, of which she has an infinite number. Her eyes reflect tenderness, her mouth is embellished with a smile, her body is the perfection of shapeliness. One morning, on returning from the observatory, I called her to undress me. She did not hear. I went to her room, which was next to mine, and I saw her at the window, leaning out, half-naked, waving across the valley, and blowing kisses from her hand, her entire soul seeming to follow after them. I had no concept of love: my eyes beheld the expression of this sentiment for the first time. I was so disturbed and surprised that I stood there still as a statue. Zulica turned round. The hazel colouring of her breast was flushed a deep pink that spread through her whole body. I too blushed, then paled, on the point of fainting. Zulica caught me in her arms, and her heart, which I felt

beating against mine, communicated to me the turmoil that ruled her senses.

Zulica hurriedly undressed me, and when she had put me to bed, she seemed to go with pleasure and to close the door with even more pleasure. Soon afterwards I heard the footsteps of someone entering her bedroom. An impulse as swift as it was involuntary made me run to the door and put my eye to the keyhole. It was the young mulatto Tanzai. He was walking towards her, holding a basket filled with wild flowers he had just gathered. Zulica ran to meet him, took handfuls of the flowers and pressed them to her bosom. Tanzai leant forward to breathe their perfume, emanating with his mistress's sighs. I distinctly saw a shiver run all through Zulica's body, and it seemed that I felt it with her. She fell into Tanzai's arms, and I went back to bed to hide my shame and weakness.

My bed was soaked with tears. Sobs choked me and in the extremity of my distress I cried out: "Oh, my one-hundred-and-twelfth progentrix, whose name I bear, sweet loving wife of Isaac, if from the bosom of your father-in-law, Abraham, you see what state I am in, appease the shade of Mamoun, and tell him his daughter is unworthy of the honours he reserves for her."

My cries woke my brother. He came into my room, and thinking I was ill, he gave me a sedative. He returned at midday, and finding my pulse was fast, he offered to continue my cabbalistic operations for me. I accepted, for it would have been impossible for me to do the work. I fell asleep towards evening, and my dreams were very different from those I had dreamt until then. The next day I dreamt while awake, or at least my absent-mindedness might have given that impression, and I blushed for no reason when my brother looked at me. A week of this went by.

One night my brother came into my bedroom. He carried under his arm *The Book of Sefiroth*, and in his hand a star-spangled sash, on which were written the seventy-

two names that Zoroaster gave to the constellation of Gemini.

"Rebecca," he said, "Rebecca, the state you are in dishonours you. Free yourself of it. It is time you tested your power over the elemental nations. This star-spangled bandeau will protect you against their boisterousness. Choose, in the mountains round about, the place you consider most suitable for your operations. Remember, your fate depends upon it."

Having said this, my brother dragged me outside the castle entrance and locked the gate behind me.

With none but myself to fall back on, I summoned up my courage. The night was dark. I was barefoot, with my hair loose, dressed only in a nightshirt, holding a book in one hand and the magic bandeau in the other. I headed for the mountain that seemed nearest. A shepherd tried to lay hold of me. I beat him off with the hand in which I held my book, and he fell dead at my feet. This will not surprise you once you know that the cover of my book was made of the wood of the Ark, which had the power of killing all that touched it.

The sun was beginning to appear when I reached the summit I had chosen for my operations. I could not begin until midnight the following day. I took shelter in a cave. There I found a bear with its young. She came rushing at me, but the binding of my book did its work: she fell down at my feet. Her swollen dugs reminded me that I was dying of hunger, and I still had no genie, not even the humblest sprite, to carry out my orders. I decided to throw myself on the ground beside the bear and suck her milk. A lingering heat in the animal made this meal less disgusting, but the little bear-cubs wanted it for themselves. Imagine, Alphonse, a girl of sixteen, who had never left the confines of the place where she was born, finding herself in this dreadful situation. I had some fearsome weapons at my disposal, but I had never used them, and the least mistake could turn them against me.

Meanwhile, I saw the grass wither, the air grew heavy with a fiery vapour, and the birds expired in midflight. I believed that the evil spirits, put on their guard, were beginning to assemble. A tree spontaneously burst into flames; swirls of smoke emerged from it that instead of rising up surrounded my cave and plunged me into darkness. The she-bear at my feet seemed to revive and its eyes glinted with a fieriness that for a moment dispelled the gloom. A devil then came out of its mouth, in the shape of a winged serpent. It was Nemrael, demon of the lowest order, who was destined to serve me. But soon afterwards I heard voices speaking the language of the grigori, the most illustrious of the fallen angels, and I realized that they were doing me the honour of assisting at my reception into the world of intermediary beings. This language is the same in which the first book of Enoch is written, a work that I had studied in particular depth.

Finally Semiaras, Prince of the Grigori, came to me and announced that it was time to begin. I emerged from my cave, I laid down in a circle my star-spangled sash, I opened my book and read out loud the dreadful formulas I had until then dared only to read. You will understand, Signor Alphonse, that I cannot tell you what happened next, and in any case you would not understand. All I shall tell you is that I acquired quite considerable power over the spirits, and that I was taught how to make myself known to the Celestial Twins. At about that time, my brother saw the tips of the feet of Solomon's daughters. I waited until the sun entered the sign of Gemini, and I in turn set to work. I left nothing to chance in my pursuit of total success. And so as not to lose the thread of my combinations, I worked on so late into the night that finally, overcome by sleep, I was forced to yield to it.

The next day, looking into my mirror, I saw two human figures that seemed to be standing behind me. I turned and saw nothing. I looked into the mirror and saw them again. Actually, there was nothing frightening about this apparition. I saw two young men, just a little

larger in stature than a human being. Their shoulders were also a little broader, but with a roundness reminiscent of our sex. They were high-chested, like a woman, but with a manly breast. Their arms, rounded and perfectly formed, lay against their sides in the manner of Egyptian statues. Their hair was gold and azure, and fell in heavy tresses on their shoulders. I will say nothing of their facial features – you can imagine how beautiful demi-gods are. For these were indeed the Celestial Twins. I recognized them by the little flames that burned over their heads.

"How were these demi-gods dressed?" I asked Rebecca.
 "They wore nothing at all," she replied.

They each had four wings, two of which lay in repose on their shoulders, while the other two folded over each other at the waist. These wings were, in truth, as transparent as the wings of a fly, but woven through with purple and gold in places, concealing all that might have offended modesty.

 So here they are, I said to myself, the celestial spouses to whom I am destined. I could not help inwardly comparing them with the young mulatto who adored Zulica, but I was ashamed of the thought. I looked in the mirror. The demi-gods seemed to be giving me a very stern look, as though they had read my mind and taken offence at my instinctive comparison.

 For several days I dared not raise my eyes to look in a mirror. At last I ventured to do so. The Divine Twins had their arms crossed on their breasts, and a look full of tenderness that dispelled my timidity. Yet I did not know what to say to them. To escape my predicament, I went to fetch a volume of the works of Edris, whom you call Atlas. This is the finest poetry we have. The harmony of Edris's verses reflects that of the celestial bodies. This author's language is not familiar to me, and fearing that I

might have misread it, I stole a glance in the mirror to see what effect I was having on my listeners. I had every reason to be satisfied. The Thamim were exchanging apparently approving looks, and occasionally they directed their glances to the mirror; I could not meet their gaze unperturbed.

My brother came in at that moment and the vision faded. He spoke to me about the daughters of Solomon, the tips of whose feet he had seen. He was very cheerful, and I shared his joy. I too was filled with a feeling so far unknown to me. The inward thrill that usually accompanies cabbalistic operations was imperceptibly giving way to some ineffably sweet abandonment of whose delights I had so far been ignorant.

My brother had the castle gate opened for the first time since my excursion into the mountains. We enjoyed the pleasures of the walk. To my eyes, the countryside seemed enamelled with the most beautiful colours. I also saw in my brother's eyes some nameless ardour very different from the passion for study. We walked through an orange grove, I dreaming my dreams and he dreaming his, and we came home still filled with our reveries.

When preparing me for bed, Zulica brought me a mirror. I saw that I was not alone. I had her take the mirror away, convincing myself, like the ostrich, that I would not be seen as long as I could not see. I went to bed and fell asleep. But soon strange dreams seized my imagination. I seemed to see in the heavens' abyss two brilliant stars progressing majestically through the zodiac. All of a sudden they were gone; then they reappeared, bringing with them the nebula of Auriga's foot.

These three celestial bodies together continued their ethereal course. Then they stopped and took on the appearance of a fiery meteor. Next they appeared to me in the form of three luminous rings that whirled around for a while before all concentrating on the same centre. Then they changed into a kind of nimbus or aureole, surrounding a sapphire throne. I saw the Twins holding out their

arms to me and indicating the place where I should sit between them. I wanted to spring forward, but it was as though the mulatto Tanzai was preventing me by gripping me round the waist. I was in fact so taken aback, I woke with a start.

My room was in darkness, and I saw from the chinks round the door that Zulica had a light on in her room. I heard her moan and thought she was ill. I ought to have called out to her; I did no such thing. I do not know what guilty impulse made me resort again to looking through the keyhole. I saw the mulatto Tanzai taking liberties with Zulica that so horrified me my blood ran cold, my eyes closed and I fell into a faint.

When I came to, I saw at my bedside my brother and Zulica. I gave her a withering look and told her never again to appear before me. My brother asked the reason for my harshness. Blushing, I told him what had happened to me. He replied that he had married the couple the previous day, but that he was very vexed, not having foreseen the consequences. In truth, it was only my eyes that had been violated, but the extreme sensitivity of the Thamim gave him cause for worry. As for myself, I had lost all feeling, except that of shame, and I would sooner have died than looked into a mirror.

My brother did not know the nature of my relations with the Thamim, but he knew I was no longer a stranger to them. And seeing that I was letting myself decline into a kind melancholy, he feared I might neglect the operations I had begun. When the sun was about to leave the sign of Gemini, he thought he ought to warn me. I woke as from a dream. I trembled at the thought of not seeing my gods again, of being parted from them for eleven months, without even knowing what I was to them, and whether I had not made myself completely unworthy of their attention.

I determined to go to a high-ceilinged room in the castle where there was a twelve-foot high Venetian mirror. But to disguise my discomposure, I took with me the volume

of Edris, which included his poem on the creation of the world. I sat a very long way from the mirror, and began to read aloud.

Then breaking off and raising my voice, I dared to ask the Thamim if they had witnessed these marvels. Thereupon the Venetian mirror left the wall on which it was hanging and came to rest before me. In it I saw the Twins smiling at me with an air of satisfaction, and both bowed their heads to convey to me that they had indeed been present at the creation of the world, and that everything had happened just as Edris described it.

Then I grew bolder. I shut my book and met the gaze of my divine lovers. This momentary abandonment nearly cost me dear. There was still too much humanity in me to be able to withstand such intimate communication. The celestial flame that burned in their eyes almost consumed me. I lowered my gaze, and having recovered myself somewhat, I continued with my reading. But it so happened that the poem I turned to was the second canticle, in which this first among poets describes the amours between the sons of Elohim and the daughters of men. It is impossible today to imagine the way they loved in the world's first age. Such extremes of loving, which I did not properly understand, often made me hesitate. At those moments my eyes turned despite themselves to the mirror, and I thought I saw the Thamim take increasing pleasure in this reading. They held out their arms to me; they came close to my chair. I saw them unfold the lustrous wings on their shoulders. I even discerned a slight quiver in the wings that served to gird them. I thought they were going to unfold these as well, and I covered my eyes with my hand. In the same instant I felt a kiss upon it, as well as on the hand that held my book. And also in the same instant, I heard the mirror shatter into a thousand pieces. I realized that the sun had left the sign of Gemini and that they had taken leave of me.

The next day I noticed in another mirror what looked like two shadows, or rather the merest outline of my

divine lovers' traits. The following day I saw nothing at all. So, to charm away the grief of absence, I spent the nights in the observatory, and with my eye to the telescope, I tracked my lovers until their setting. Even after they had dropped below the horizon, I fancied I could see them still. At last, when the tail of Cancer disappeared from sight, I too would go to rest, and my bed was often bathed with tears that came of their own accord, for no reason.

Meanwhile, filled with love and hope, my brother devoted himself more than ever to the study of the occult sciences. One day he came to me and said that certain signs he had noticed in the sky had told him that a famous practitioner of the art, who for two hundred years had been living in the pyramid of Saophis, had set out for America and would be passing through Cordoba on the 23rd of our month of Thybi at forty-five minutes past midnight.

I went that evening to the observatory and discovered that he was right. But my calculation gave me a slightly different result. My brother maintained that his was correct, and since he is firmly wedded to his opinions, he wanted to go himself to Cordoba to prove his case. My brother could have made this journey in as little time as it takes me to tell you about it, but he wanted to enjoy the pleasures of the excursion, and followed the contours of the hills, choosing the route whose picturesqueness would afford him most delight. So it was that he came to Venta Quemada. He had taken with him Nemrael, the devil that appeared to me in the cave. My brother ordered him to bring some supper. Nemrael stole the supper from a Benedictine prior and brought it to the Venta. Then, having no further need of him, my brother sent Nemrael back to me. I was at the time in the observatory, and I saw in the sky things that made me fear for my brother. I ordered Nemrael to return to the Venta and on no account to leave his master. Off he went, and came back a moment later to tell me that a power greater than his own had

prevented him from gaining access to the inn. My anxiety knew no bounds. At last I saw you arrive with my brother.

I read in your features a self-confidence and serenity that showed me you were no cabbalist. My father had told me that a mortal would cause me great suffering. I feared you might be this mortal. Soon other cares filled my mind. My brother told me Pacheco's story, and of his own experiences. But to my great surprise, he added that he had no idea what kind of demons he had been dealing with. We awaited nightfall with extreme impatience. At last it came, and we carried out the most dreadful conjurations. To no avail: we were unable to discover either the nature of those two beings, or whether through them my brother had in fact lost his claim to immortality. I thought we might extract from you some light on this. But faithful to some oath or other, you refused to say anything.

Then, in order to help my brother and set his mind at rest, I determined to spend a night at Venta Quemada, and I set off yesterday. It was already late into the night when I reached the entrance to the valley. I gathered some trails of mist, of which I fashioned a will-o'-the-wisp, and I instructed it to lead the way. This is a secret that has remained in our family, and it was by similar means that Moses, blood brother to my sixty-third ancestor, made the pillar of fire that led the Israelites through the desert.

My will-o'-the-wisp burned brightly and began to walk ahead of me, but it did not take the shortest route. I noticed this lapse, but did not pay enough attention to it.

It was midnight by the time I got there. As I came into the Venta's courtyard, I saw a light in the middle room, and heard some harmonious music. I sat down on a stone bench and performed several cabbalistic operations that achieved absolutely nothing. It is true that this music so captivated and distracted me that I cannot now tell you whether my operations were well done, and I think I must have overlooked some essential step. However, I thought I had done them properly, and believing there to be

neither demons nor spirits in the inn, I concluded there were only men, and I surrendered to the pleasure of listening to them sing. There were two voices, accompanied by a stringed instrument, but they were so perfectly attuned and so harmonious, no music on earth can compare.

The songs these voices sang inspired a tenderness so alluring it defies all description. For a long time I listened to them from my bench, but at last I decided I must go in, having come for that sole purpose. So I went upstairs and in the middle room I found two young men, both tall and handsome, seated at a table, eating, drinking and singing their hearts out. Their dress was oriental; they wore turbans on their heads, their chests and arms were bare, and they had costly weapons in their belts.

These two strangers, whom I took for Turks, rose, drew up a chair for me, filled my plate and my glass, and resumed their singing to the accompaniment of a lute, which they took turns to play.

There was something infectious about the casualness of their manner. They did not stand on ceremony, and nor did I. I was hungry, and I ate. There was no water, so I drank wine. Then I was seized with the desire to sing with the young Turks, who seemed enchanted to hear me do so. I sang a Spanish seguidilla. They responded, rhyme for rhyme and thought for thought.

I asked them where they had learned Spanish.

One of them replied: "We were born in the Morea, and are sailors by profession. It was easy for us to learn the language of the ports we frequented. But enough of seguidillas. Listen to the songs of our country."

Their songs had a melodiousness that led the soul through every shade of feeling, and when one had reached the extremity of tenderness, unexpected strains in the music brought the listener back to the craziest merriment.

I was not taken in by this ploy. I carefully studied the supposed sailors, and thought I saw a close resemblance between them, and a strong likeness to my divine Gemini.

"You are Turks," I said, "and were born in the Morea?"

"Not at all," replied the one who had not yet spoken. "We are Greeks, born in Sparta."

"Ah! divine Rebecca," continued the other, "can you fail to recognize us! I am Pollux and this is my brother!"

Terror robbed me of the use of my voice. The supposed Twins spread their wings. I felt myself raised through the air, but by a happy inspiration, I pronounced a sacred name of which only my brother and I are in possession. In that very instant I was dashed to the ground. My fall made me lose consciousness, and it was through your ministrations that I regained it. I have a firm conviction that I lost nothing of what it was important for me to preserve. But I am weary of so many wonders. Divine Twins, I have the feeling I am unworthy of you. I was born to remain an ordinary mortal.

Here Rebecca ended her story, but it did not have the effect on me she expected. Despite all the extraordinary things I had seen and heard in the last ten days, I could not help thinking she had tried to make a fool of me. I left her rather discourteously, and as I began to reflect on what had happened to me since leaving Cadiz, I then recalled a few words that Don Emanuel de Sa, Governor of that city, had let slip, which made me think he was not totally unacquainted with the mysterious existence of the Gomelez. It was he who had given me my two manservants Lopez and Mosquito. I took it into my head that it was on his order that they had left me at the ill-omened entrance to Los Hermanos. My cousins, and Rebecca herself, had often given me to understand that I was being tested. Perhaps at the Venta I had been given a drink to make me sleep, and then nothing could have easier than to transport me in my sleep and leave me lying beneath the fateful gibbet. Pacheco might have lost an eye through some accident quite other than his amorous liaison with the two hanged men, and his dreadful story could be a

fabrication. The hermit, who had always tried to ferret out my secret, was doubtless an agent of the Gomelez, who wanted to try my discretion. Finally, Rebecca, her brother, Zoto and the gypsy chieftain – all these people were perhaps conspiring to shake my courage.

These reflections, as anyone will appreciate, persuaded me to await resolutely the sequel to the adventures for which I was destined. The reader will learn what happened next if the first part of my story is well received.